DRAWING
ARCHITECTURE

The beginner's guide to drawing and painting buildings

Richard Taylor

DAVID & CHARLES

www.davidandcharles.com

A DAVID AND CHARLES BOOK
© David and Charles, Ltd 2022

David and Charles is an imprint of David and Charles, Ltd
Suite A, Tourism House, Pynes Hill, Exeter, EX2 5WS

Text and Artwork © Richard Taylor, 2005
Layout © David and Charles, Ltd 2022

First published in the UK and USA in 2005 as Drawing and Painting Buildings

A catalogue record for this book is available from the British Library.

ISBN-13: 9781446309520 paperback
ISBN-13: 9781446382080 EPUB
ISBN-13: 9781446382073 PDF

This book has been printed on paper from approved
suppliers and made from pulp from sustainable sources.

Printed in the UK by Page Bros for:
David and Charles, Ltd
Suite A, Tourism House, Pynes Hill, Exeter, EX2 5WS

10 9 8 7 6 5 4 3 2

Commissioning Editor Mic Cady
Desk Editor Lewis Birchon
Art Editor Lisa Wyman
Design Assistant Sarah Clark
Production Controller Kelly Smith

David and Charles publishes high-quality books on a wide range of subjects.
For more information visit www.davidandcharles.com.

Layout of the digital edition of this book may vary depending on reader hardware and
display settings.

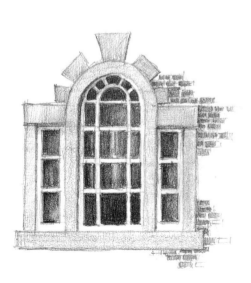

Contents

Introduction

The wonderful thing about drawing buildings is that, wherever you travel around the globe, you will never be short of subjects to inspire you. From the most elaborate of Renaissance cathedrals, through to the humble garden shed, you will always be able to practise your skills and learn a few techniques in the process.

As this book is primarily concerned with the methods and techniques employed in drawing buildings, I have not dwelt in any depth on architectural history or heritage, although this aspect cannot simply be dismissed. The buildings of any district bear witness to its past, and many

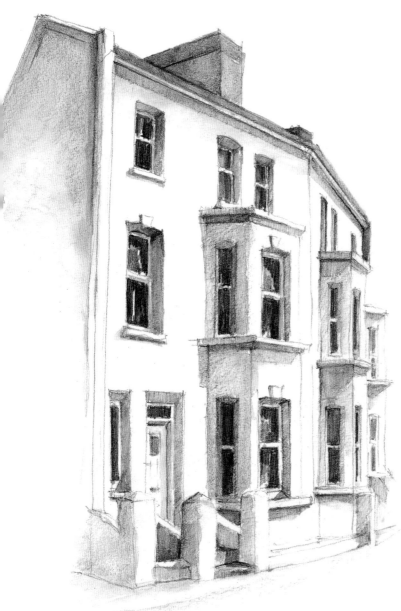

modern buildings may help us to look towards the future, too. Furthermore, as you begin to develop the confidence to sketch on site, I am sure that you will also begin to absorb much of the history that has created the buildings that you are drawing.

How to use this book

As you work through this book, you will find that I have devoted each double-page spread to a specific theme: I look at materials and their qualities at the beginning, and then move on to explore how to put these materials to best use when drawing specific types of building. You will also find that you will be led gently through levels of learning, with a reasonably easy exercise always preceding a slightly more challenging one. I have never had any difficulty in combining the two elements of my working life – artist and teacher – and always tend to think about progression of knowledge and development of skills.

As the book is divided into discrete sections, you can dip in to any particular type of building that you wish to draw, and use the information and illustration provided.

The projects may be identified more as extended teaching exercises, taking you through the way I approach composing and completing a drawing. They show not just the way that I work, but also the way I think about putting together a drawing.

Size and scale

The majority of the illustrations throughout this book are reproduced very near to their original scale. I generally use an A3 (16½ by 11½in) sketchpad to draw in, which is not very much larger than the open double pages of this book. I believe that these full-size illustrations will give you a good indication of the way in which I draw, and the way in which you can learn by copying the exercises and using the suggested media on a similar scale.

Photographs

I have used photographs on a couple of pages to illustrate just how useful they can be as a visual reminder. Many artists work from photos – but few do so exclusively. The slavish copying of flat images is not to be recommended. Much of the pleasure of drawing and sketching buildings comes from finding a building that grabs your interest, and applying your drawing skills while you are on site. The excitement of making the first mark on a blank sheet of paper, the intense concentration as you trace the lines of rooftops with your eye, and the feeling of total oblivion (albeit temporary) to the world around you as you sketch and draw on the streets of your chosen venue cannot ever be replaced by the simple click of a shutter.

You can learn to draw: maybe not in a day, but it can be done. Drawing is a very absorbing activity, and practice will help you to improve your technique. My advice is to practise regularly – drawing for ten minutes a day, every day, will allow you to develop your eye and train yourself to translate the three-dimensional built environment around you into fascinating two-dimensional sketches.

Finally

I hope that this book opens your eyes to see inspiration in the built environment from areas other than the traditional roof, doors, windows and four-wall structures – there is so much more to find!

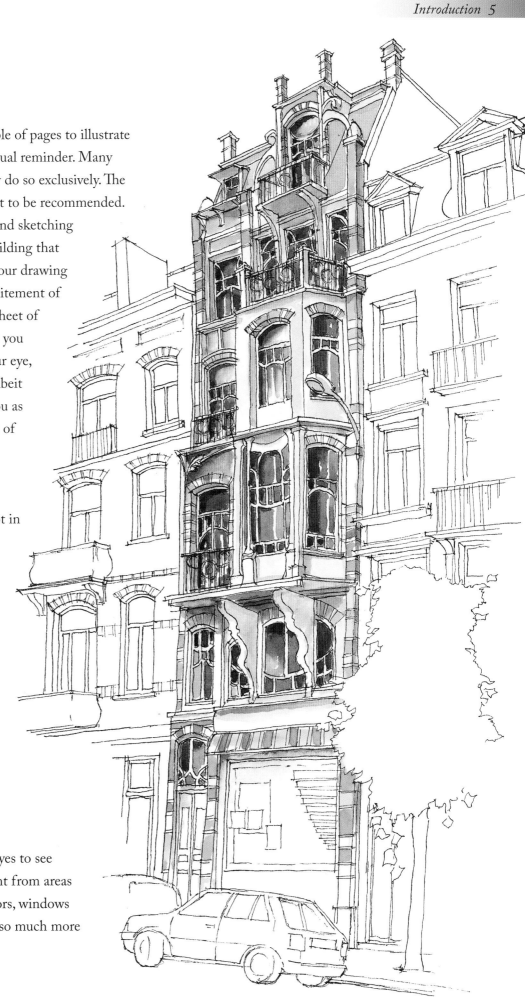

MATERIALS

I use a limited number of mark-making tools, and have no preference for particular brands. My main tools for sketching trips are graphite pencils. I always carry a 2B, 4B, 6B and 8B pencil with me. These will deal with most of the tones that you are likely to see in the built environment. I also use water-soluble graphite pencils, because these can provide some of the qualities of line and wash, while still drawing like pencils.

I use two different types of pen: a fibre-tip writing pen (the cheaper the better), and a draughtsman's ink pen. The ink from fibre-tip pens is not usually waterproof and will bleed if washed over, as opposed to the draughtsman's ink pens. Both types have their uses, and come in a variety of sizes and colours. I also tend to carry a small bottle of Indian ink with me, as well as water for diluting the ink. I also take small (size 1) and medium (size 8) soft watercolour brushes with me for tinting drawings.

Sketchpads and artists' paper can be a major source of confusion – there are so many different types to choose from! My personal preference is for an A3 (16½ by 11½in) hard-backed cartridge paper sketchpad. Good cartridge paper will allow you to work with all media. It is usually sufficiently robust to stand up to several light washes of diluted ink or watercolour paint.

I also carry a compact camera with me on sketching trips. Although a camera has its limitations, it can be a valuable tool for recording the more complex facets of buildings or for capturing vistas that are simply too large to sketch at one sitting, allowing you to refer back to your photos in the safe confines of your home.

When making a studio painting, I occasionally want to draw on a larger scale, but I still stick with strong cartridge paper. This is not textured like watercolour paper, but maintains a certain 'tooth' to grip and hold graphite. I will sometimes use graphite powder on large sheets of paper. Graphite powder is commercially available, although you may need to visit a specialist art store to find it. The joy of using graphite powder lies in the physicality of its application.

As you draw buildings more regularly, you will begin to develop a preference for particular media and will build up your own drawing kit accordingly. In the meantime, however, a pencil and a sheet of paper are all that you need to get started.

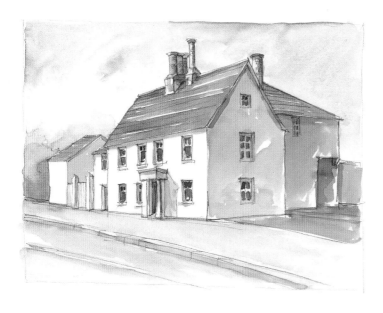

PENCILS

Pencils are the medium most commonly associated with the art of drawing. Although you can make marks with any type of pencil, there is a group of pencils that is produced specifically for artists. These are the B pencils, which contain soft compressed graphite. These pencils range from the straightforward, relatively hard, B grade, through to the extremely soft, deep black 9B.

The softer the pencil that you use, the easier you will find it to create strong, deep shadows without damaging the surface of your paper through exerting too much pressure.

When drawing with pencils, there are two basic techniques that you can employ. Firstly, by drawing with only the tip of the pencil lead in contact with the paper, you will get a sharp, thin line. This technique is good for producing sketches and outline images. It can also be refined more to develop types of shading, such as cross-hatching (see below). Next, you can lower the angle of the pencil so that the side of the pencil lead is in contact with your paper. This technique allows you to create soft-edged shading, and is ideal for quickly filling in areas of space or creating specific shadows.

Pencil grades

You will probably find it best to start drawing with a 2B pencil to create the basic outline of your building. You can then establish the middle tones with a 4B pencil, before moving on to complete the image by the addition of the deep, dark areas with a 6B pencil. As your confidence in pencil shading grows, you may want to graduate to an 8B pencil for shading.

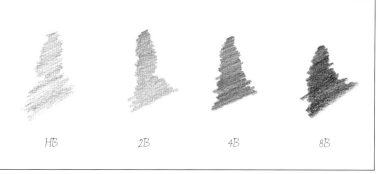

HB 2B 4B 8B

Techniques

These pencil techniques are best practised on cartridge paper: it is not textured but has a slight 'tooth' for the graphite to cling to.

Line shading using the tip of the pencil.

Soft shading using the edge of the pencil lead.

Cross-hatching.

Cross-hatching on soft shading is a good technique for creating hard-edged shadows.

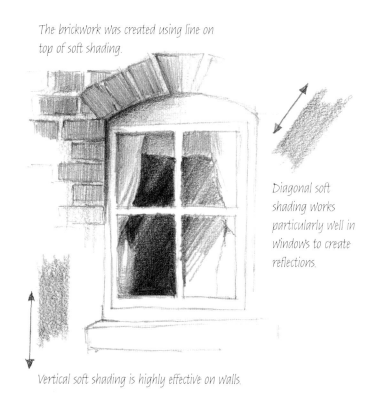

The brickwork was created using line on top of soft shading.

Diagonal soft shading works particularly well in windows to create reflections.

Vertical soft shading is highly effective on walls.

Boston townhouse (*pencils continued*)

The strong, angular shapes of this building are emphasized
by the shadows. These can be recorded effectively by drawing
diagonally across the paper to reinforce the effect of the lighting.

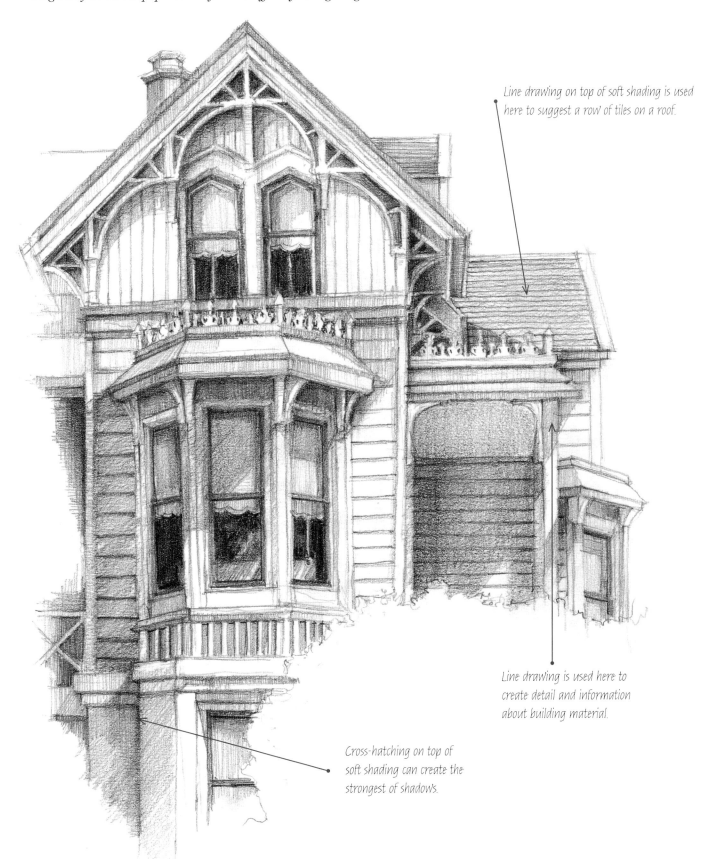

Line drawing on top of soft shading is used
here to suggest a row of tiles on a roof.

Line drawing is used here to
create detail and information
about building material.

Cross-hatching on top of
soft shading can create the
strongest of shadows.

GRAPHITE POWDER

Graphite powder is a soft, velvety powder with little texture. Texture can be created by the use of a slightly rough-surfaced paper. Graphite powder is used for quickly filling in large areas and for reproducing the effect of soft plaster or stone.

Once the graphite powder is on the paper, you can alter the tone by introducing a very soft pencil such as a 6B or 8B. This has two advantages. First, you can draw over the graphite powder and increase the depth of tone in the drawing considerably, especially if you use the edge of an 8B pencil. Second, you will find that applying graphite powder with your fingers tends to leave you with some ill-defined outer edges. While this may be perfectly fine for recording shadows, it will not, for example, be so good for rendering decorative carvings. Using a pencil in addition to the graphite powder allows you to sharpen edges and define specific shapes while retaining the softness of the main area of toning.

One other graphite powder technique that is useful is sprinkling. This will allow you to create the appearance of a weather-beaten texture. Simply sprinkle a small amount of powder on to a light section of paper and spray this with fixative straight away to hold the loose particles on to the paper's surface.

Techniques

Graphite powder is best applied with your fingers, direct from the pot. Simply create your line drawing, dip your finger into the powder and enjoy the tactile experience of rubbing it into the surface of a strong sheet of cartridge paper. You will need to be quite vigorous, as the powder will blow away or fall off if not worked well into the fibres. You can then alter the tone by using one or more additional applications on top of each other to increase the depth of tone, or by lifting some of the powder off with the tip of a putty rubber if you want to lighten a section.

Sprinkle graphite powder to create textures, then spray with fixative to hold the powder on to the paper.

Graphite pencil (6B or 8B) works well when drawn over graphite powder. It helps to give definition.

You need to get your hands dirty when using graphite powder. Dip your fingers into the velvety powder and rub it into the paper.

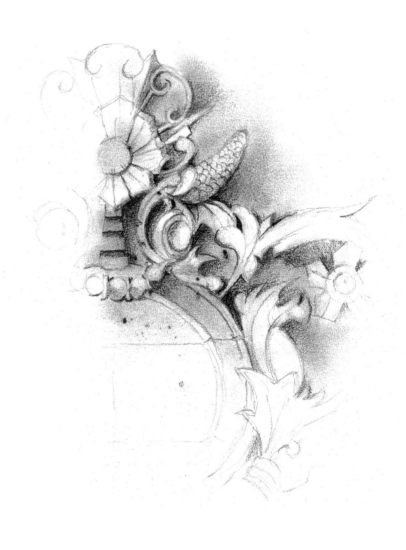

This study makes full use of pencil and graphite powder. Pencil may be used to spread the powder as well as to strengthen shaded areas.

WATER-SOLUBLE GRAPHITE PENCILS

Water-soluble graphite pencils are made of soft graphite, held in a little gum. With the application of a wet brush, they produce a watercolour-type wash. These pencils are useful because they allow you to retain some of the accuracy and solidity of a pencil while introducing the softness and fluidity of a watercolour painting – albeit all in tones of grey.

When working with water-soluble graphite pencils, it is worthwhile noting that they generally appear much darker when they are wet. This means that they will eventually dry to a slightly lighter tone than was indicated by the original drawing. As with all aspects of drawing, a combination of techniques is most likely to give you the most satisfactory results.

Techniques

Water-soluble graphite pencils are highly flexible drawing tools that can be used in a variety of ways. They also come in a selection of grades. The most common technique is to draw as normal, using the tip of the pencil to create the basic shape, and establishing the tones with the edge of the lead. Then, with a wet paintbrush, wash gently over the entire drawing. This softens the gum, releasing the graphite pigment into the water, and creating a monochrome watercolour wash effect.

Medium. *Soft.* *Drawing with wet pencils – medium.* *Drawing with wet pencils – soft.*

Lighthouse

The way in which this lighthouse stood against the sky made it a clear choice for a medium that could be washed.

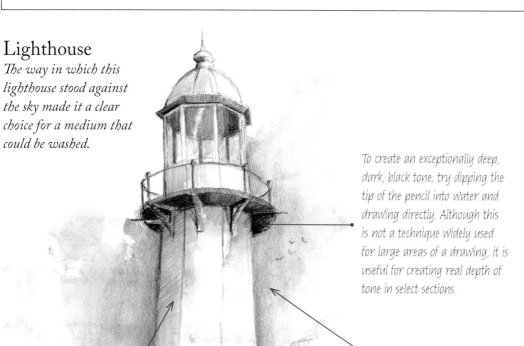

To create an exceptionally deep, dark, black tone, try dipping the tip of the pencil into water and drawing directly. Although this is not a technique widely used for large areas of a drawing, it is useful for creating real depth of tone in select sections.

Drawing with a dry pencil across washed shading. Once a drawing has dried, you can draw on to it again with the tip of a dry pencil to reinforce any lines or shapes that have become too diluted with the wash.

A strong wash across soft shading provides an even tone. White buildings stand out well against this.

Dry pencil drawn on to a dried wash allows for a sense of shape to be created.

Eastern gateway

The success of this drawing relies upon the idea of 'sandwiching' the building between the sky and foreground. Using water-soluble graphite pencils helps to enhance this effect.

The architecture is highlighted by the use of a graphite wash in the background.

Detail drawn on to the building is not destroyed by over-washing; it is just softened.

The darkest shadows are created by intense drawing (with increased pressure) prior to washing.

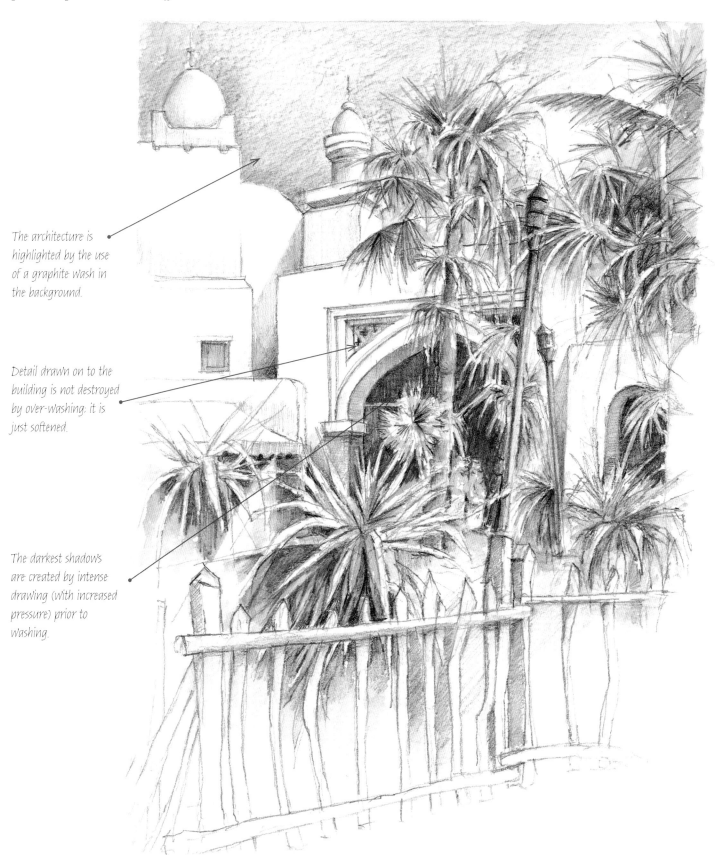

WATER-SOLUBLE COLOUR PENCILS

Water-soluble colour pencils work along the same principle as water-soluble graphite pencils, only you have the added variable of colour to work with. This means that you can create a wealth of tones within one particular colour by blending a mixture of pencils together. The effect of washing across colour pencils also gives a much more painterly effect and can vary the style of marks made.

You may find that different colour pencils vary in their reactions to each other when washed over, so it is worth experimenting to see how they react when mixed.

Although this flexible medium can be used for a wide range of subjects, it is probably best suited to recording the more detailed aspects of the built environment. Features such as roof tiles, bricks, stone, carvings, cobblestones and ironwork are all particularly suited to the soft tones and clear lines that can be created by drawing with water-soluble colour pencils.

Key colours used for drawing buildings

Ultramarine. Sap green. Orange. Burnt umber. Burnt sienna. Raw sienna.

Techniques

Draw blocks of colour with the edge of the lead; you may wish to darken the colour or alter the tone by drawing another set of colours on top. Once you are satisfied, wash over the pencil with a soft, wet watercolour brush. This will raise the coloured pigment and dissolve it, creating the effect of a watercolour wash that will dry to a lighter tone than the original drawing. To add more colour, detail or general interest, draw on top of the dried colour and wash over it again. While the colours will remain translucent, this will darken, or strengthen, the picture.

Using a soft brush, wash across dry pencil marks to create a paint-like effect.

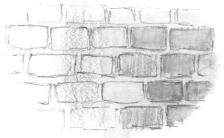

One pencil colour was laid on top of another and then washed over with clear water to achieve this brickwork effect.

Raw sienna was used as the under-colour.

Burnt sienna was added to create the brick colour on top of the raw sienna.

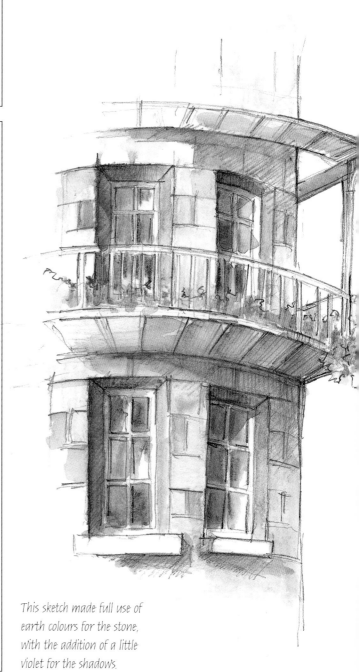

This sketch made full use of earth colours for the stone, with the addition of a little violet for the shadows.

Quiet square

The detailed nature of this quiet square made it ideal to be recorded in water-soluble colour pencils. The important information could be drawn on, then washed over to create a loose, painterly effect.

Drawing on top of a dry wash with a coloured pencil creates darker tones to represent shadows.

Details are drawn with coloured pencil and washed over to create a paint-like effect.

Not all parts of the composition need be coloured. White paper gives life to a drawing.

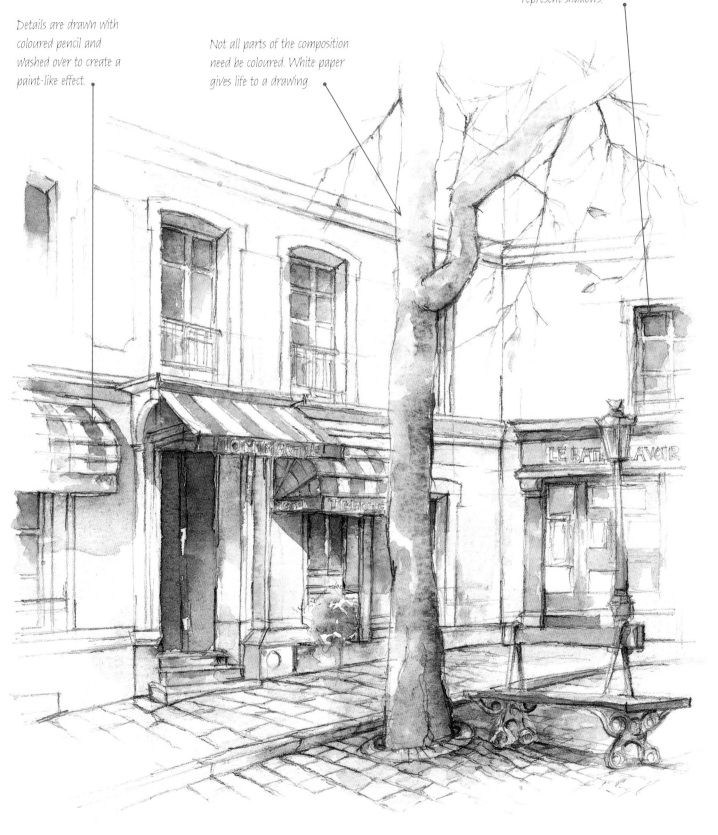

WATERCOLOUR

Watercolour paints can be used to enhance a pencil drawing in several ways. First, a wet wash of pre-mixed colour on to dry paper will result in a hard-edged image. This can be useful in creating clearly defined shadows to indicate the strength of the Mediterranean sun, for example. For a softer appearance, you may wish to use the wet-in-wet technique. This involves dampening the area of paper that you wish to paint and then applying wet paint to it. The result will be a relatively uncontrollable bleed. The paint will diffuse and soften as it slowly dries; you can use this to mix colours on the paper, and certain paints also granulate to create a textural effect.

You can also create a softer tone by mixing your colours on the paper. If you apply two or more wet colours next to each other on dry paper, they will run into each other and slowly bleed together. This is a rather unpredictable technique, but you will at least be guaranteed some spectacular textures.

Techniques

Watercolour paints can be used to good effect with a pencil drawing, especially if the subject is very light in tone and lacks specific details. Watercolour is well suited to rendering the whitewashed buildings of the Greek islands or the fishermen's cottages of many seaside towns. The key to applying watercolour paint to a pencil drawing is to let it flow. Don't worry about bleeds and runs – they will give your drawings a much more spontaneous feel.

Wash on to
dry paper.

Wash on to
wet paper.

Blending wet paints
on to dry paper.

Creating texture by blending
several colours on wet paper.

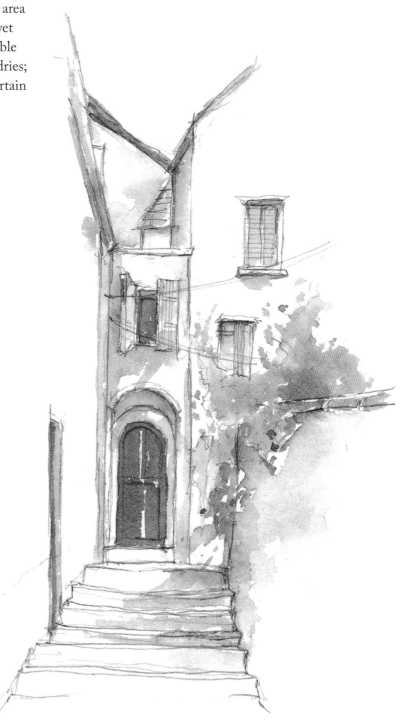

Warm colours (violet and burnt sienna) were used to capture the day in this thumbnail sketch.

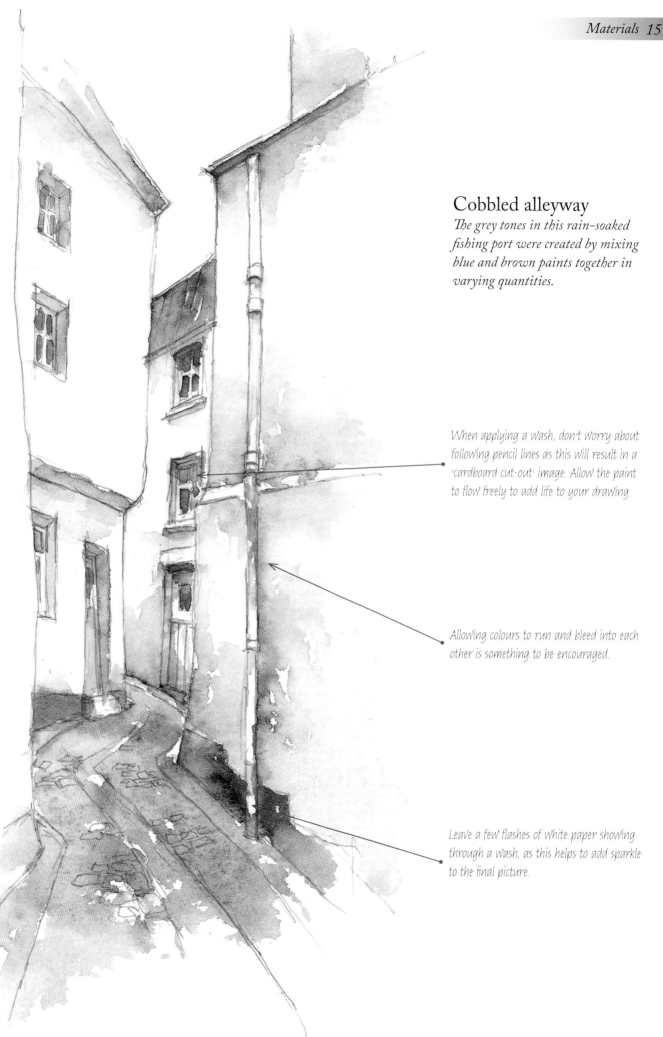

Cobbled alleyway

The grey tones in this rain-soaked fishing port were created by mixing blue and brown paints together in varying quantities.

When applying a wash, don't worry about following pencil lines as this will result in a 'cardboard cut-out' image. Allow the paint to flow freely to add life to your drawing.

Allowing colours to run and bleed into each other is something to be encouraged.

Leave a few flashes of white paper showing through a wash, as this helps to add sparkle to the final picture.

PEN LINE AND WASH

There are two types of pen that are suitable for drawing buildings: fibre-tip pens and ink pens. Fibre-tip pens glide smoothly across the paper and the quality of line will not alter regardless of how much pressure you exert. Once you have created an outline drawing, these pens offer you several options. First, you can wash across the lines with a soft, damp brush. This will cause the ink to bleed, giving you instant tone and shadow, but diluting the strength of the line. Once dried, you may then re-draw some of the building to re-establish the solidity of the linear structure. You can, of course, choose not to use water at all and create the fabric of the building through line shading

and cross-hatching. You can also scribble on to a scrap piece of paper, lift the ink from this with a wet brush and quickly transfer it to your drawing if you want to create some very subtle toning.

The second type of pen, the ink pen, requires a different approach. You will need to introduce a bottle of Indian ink to your drawing toolbox to create the widest range of tones. Draw as normal, and create the structure with lines and any line shading that you wish to include. Then add a few drops of ink to a small pot of water. Using a soft brush, you can wash this solution across your drawing without fear of the line drawing running or bleeding.

Techniques

Many different types of ink pen are available for artists, all of which have their purpose. You can even draw with a ballpoint pen if you wish! The types of pen most suited to drawing buildings are fibre-tip pens and Indian ink draughtsman's pens. The chief difference is that fibre-tip pens are often water-soluble, whereas ink pens are waterproof.

Line.

Cross-hatching.

Clear water washed across fibre-tip non-water-resistant pen softens the line, giving an ink wash effect.

Drawing on to ink wash makes lines appear sharper.

Scribble on to a piece of scrap paper and lift the ink on to a wet brush.

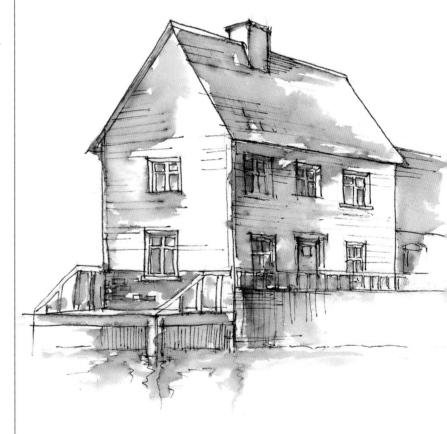

A quick line sketch with a fibre-tip pen can be given substance by selective washing. Don't forget to leave some areas of paper dry.

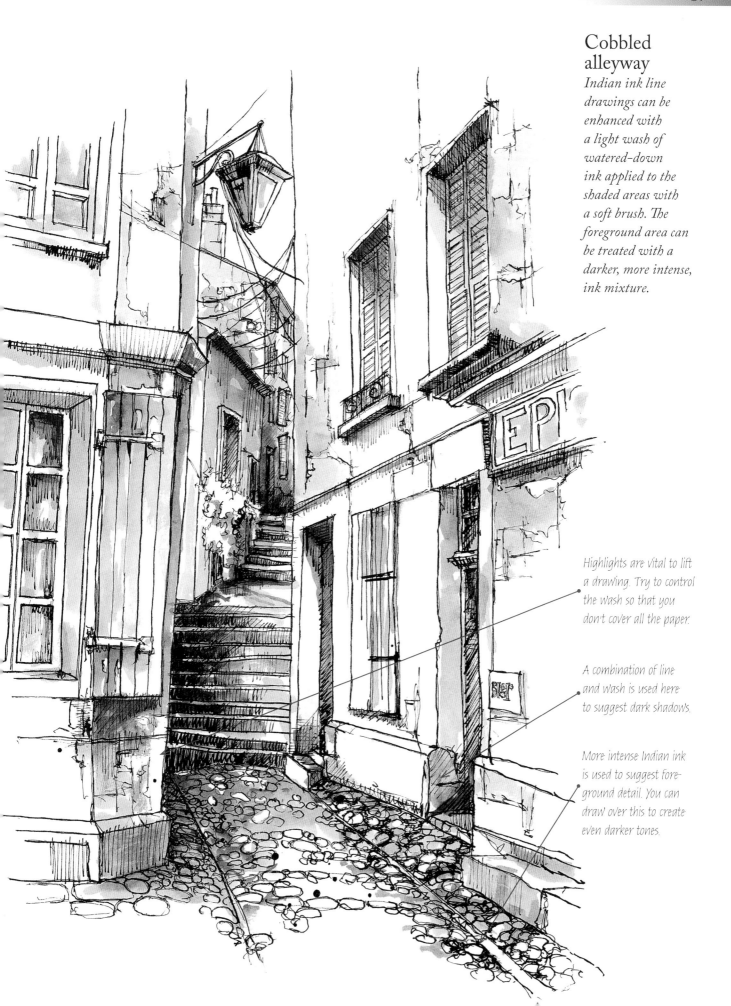

Cobbled alleyway

Indian ink line drawings can be enhanced with a light wash of watered-down ink applied to the shaded areas with a soft brush. The foreground area can be treated with a darker, more intense, ink mixture.

Highlights are vital to lift a drawing. Try to control the wash so that you don't cover all the paper.

A combination of line and wash is used here to suggest dark shadows.

More intense Indian ink is used to suggest foreground detail. You can draw over this to create even darker tones.

PEN AND COLOUR

Once you decide to add colour to enhance a pen drawing, you restrict yourself to working with non-soluble ink pens. Fibre-tip pens bleed and alter the colours of any wash considerably.

The most common colour medium used to liven up a pen drawing is watercolour paint. This is translucent and allows a pen drawing to show through any number of washes. However, the drawing may appear diffused if too many washes are laid on top of it. This can be corrected by reinforcing some pen lines by drawing over them once a watercolour wash has dried – leave some lines faint to keep some of the details in the background.

You should consider the way in which colour and line work together when deciding which medium to use. Line and colour should complement, not compete with, each other. If you have a simple line drawing, you can afford to add a selection of colours and use these to create the form of the drawing. If, however, your line drawing is already awash with lines and shapes, then use colour simply to enliven the drawing.

A strong ink line drawing on cartridge paper will not generally be diffused by a light watercolour wash.

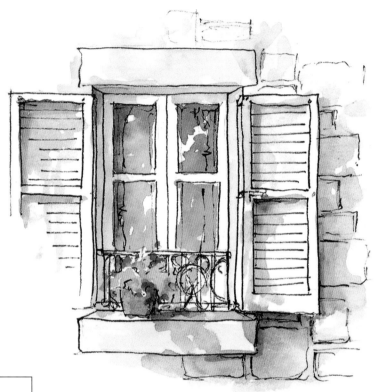

Key colours used for drawing buildings

Raw sienna.

Raw umber.

Burnt sienna.

Payne's grey.

Violet.

Sap green.

Technique

It is best to apply colour to dry paper with a medium-size watercolour brush. Mix your colours and washes in the palette before applying them, and try to use a single, one-stroke wash. This adds to the simplicity of the end result, allowing the line drawing to dominate.

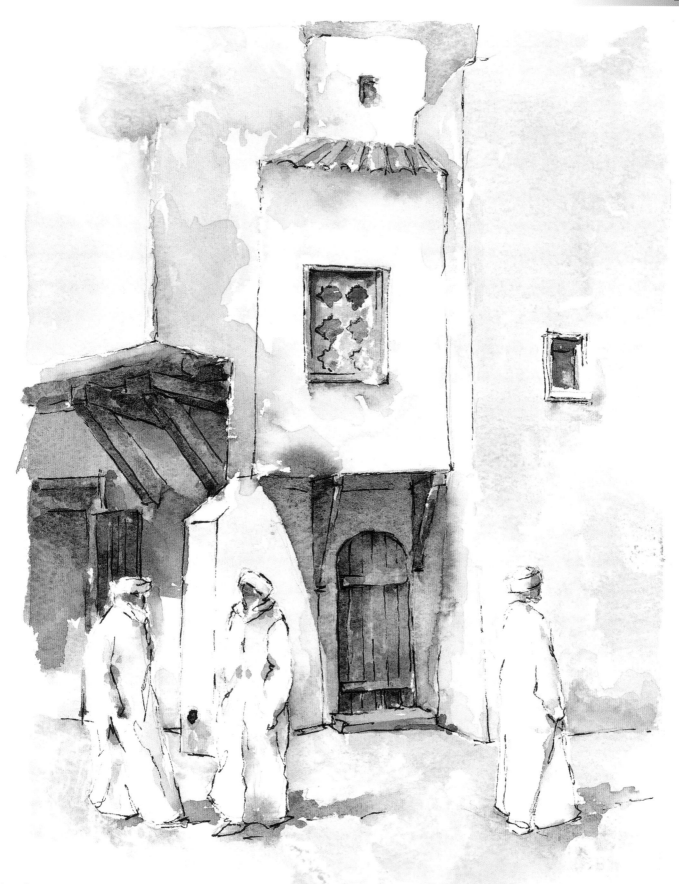

Arabian scene

Drawing with pen on to textured watercolour paper produces broken lines, allowing the paint to create the image.

MECHANICS

This section explores the nuts and bolts of the drawing process – the elements that hold a composition together. Perspective is the first key issue, and the one that often strikes fear into the hearts of more teachers than students – exactly how do you explain how it works? The answer is simple: buildings appear to become smaller the further away they are. That is the essence of perspective. It's an illusion, of course; buildings don't physically decrease in size, they just appear to. Pages 22–27 offer you some guidelines for reproducing this optical, three-dimensional illusion on a flat piece of paper.

It is easy to become caught up in the idea of 'rules' in art. We tend to refer to 'rules' of perspective and 'rules' of composition. The reality is that these rules are only suggestions as to how you might make your pictures work better for you. They have been created by artists, for the furtherance of art. They do not have to be adhered to rigidly at all times, although they are often based upon much experience and practice.

This is an appropriate section of the book to consider the idea of finish – when exactly is a drawing finished? Again, the answer is simple – the drawing is complete when you decide that it is. Only occasionally do I draw right out to the four edges of a rigid rectangle. I personally like my drawings and sketches to be surrounded by white space without a hard line confining them. You may, of course, like to fill every section of a given shape with line, tone and detail. Neither of these options are right or wrong; it is simply about personal preference.

Although the guidelines that follow in this section have been proven to work, it is important that you occasionally stretch these to their limits, and maybe beyond. View them as building blocks that you can develop, change to fit your own needs and style, and eventually make your own. Remember, there are no unbreakable rules in art; it is only by pushing the boundaries that you improve and develop your own understanding and style.

One-point perspective

In the real world of high streets, terraces and alleyways, it is unlikely that you will ever encounter a scene where you need to employ only one-point perspective; you will nearly always be able to see at least two sides of a structure. However, you will encounter many views where single-point perspective will be the dominant technique that is required.

First, you need to establish your horizon line. This will often be imaginary, as you will probably not be able to see it – in which case, draw it approximately one-third of the way up your paper. This line is now your eye line on the page. Anything above your eye level is drawn above it; anything that is below your eye level is drawn underneath it.

Next, look at the top line of the buildings as they appear to recede away from you. Imagine a point at which that line would eventually meet the horizon line and mark it on the paper. This point is known as the vanishing point, or VP. Now you can start to establish a series of construction marks or guidelines that will help you to gain a sense of proportion and form for your buildings.

The next stage is to sketch in the details that make buildings so appealing, such as doorways and windows. Start by making a few faint marks to represent the height of the windows nearest to you. Then draw a line from the top and the bottom to the vanishing point. All the other windows will sit between these lines, giving you a sound sense of proportion. Apply this technique to the doors and other details, and you will soon have an outline framework to build up into a finished drawing.

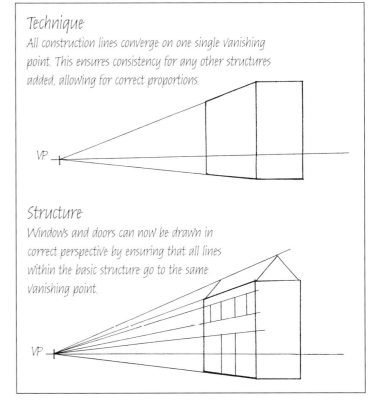

Technique
All construction lines converge on one single vanishing point. This ensures consistency for any other structures added, allowing for correct proportions.

Structure
Windows and doors can now be drawn in correct perspective by ensuring that all lines within the basic structure go to the same vanishing point.

Details
No matter how big or small buildings may be in a row, they will still share the same vanishing point.

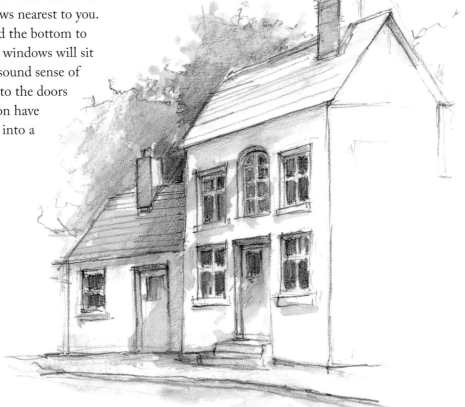

Victorian townhouse terrace

This picture was drawn from a slightly higher-than-usual viewpoint, giving the single-point perspective an odd feel. The angle of the base line is sharper than the roof line, placing the horizon line almost in the centre of the composition.

Never use rulers to draw straight lines, as this makes them look artificial. A slight wobble in converging lines can add a little life to your drawing.

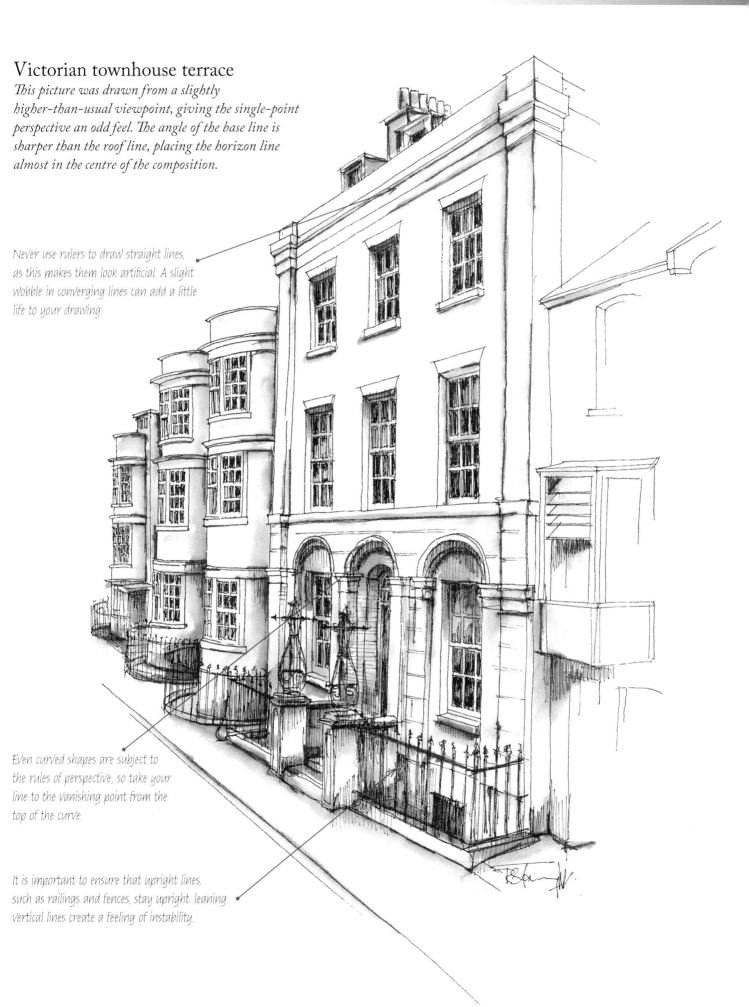

Even curved shapes are subject to the rules of perspective, so take your line to the vanishing point from the top of the curve.

It is important to ensure that upright lines, such as railings and fences, stay upright: leaning vertical lines create a feeling of instability.

Two-point perspective

Two-point perspective is the technique you are most likely to use when sketching in the built environment. This technique begins in exactly the same way as one-point perspective: first establish your horizon, but this time position yourself so that the corner of a building is facing you. You will now be able to see walls and rooftops receding to your left and to your right. This will necessitate marking two vanishing points at the far end of your horizon line. (For compositional purposes only, it is best to ensure that the corner line is offcentre. This prevents an even balance, which unsettles artists!)

The most straightforward approach is to construct a simple box. This is best achieved by establishing the height of the corner of the building facing you and marking this on your paper. Most of the line will be above your horizon. Then take a line from the top outwards to both vanishing points. Repeat this process for the lowest mark of the line. You will then have to make a judgment regarding how wide or long your building is to be by marking the outer edges along the horizon. Once you have drawn the extremities of the house within the upper and lower perspective guidelines, you will have created a perfect box in correct perspective.

The drawing can now be developed in exactly the same way as a one-point perspective drawing, only you have to repeat the procedure on both sides of the corner line. You will also find that this method is helpful in constructing shadows; these follow the same rules of perspective so you will need only to extend a few construction lines in order to establish some shadow shapes.

Technique

Construction lines from either side of the corner of the box go to their respective vanishing points. You may find that the 'box construction' system will help you in the early stages. This involves initially ignoring details such as windows and doorways, and viewing your building as a simple box.

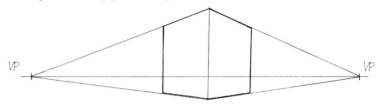

Structure

The windows and doors on either side of the box building are constructed by extending guidelines to the appropriate vanishing points.

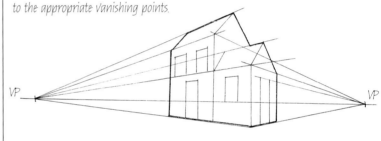

Details

You will always need to direct your attention to the way in which both sides of the building appear to recede into the distance.

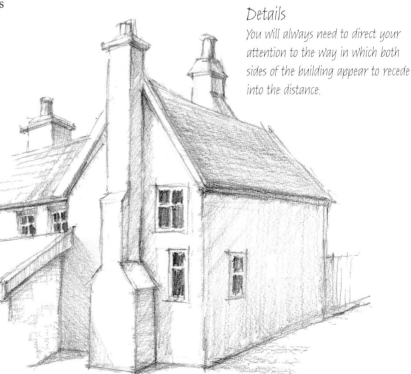

Traditional Suffolk cottage

The line of the wall extending from the cottage gave several corners to consider as focal points.

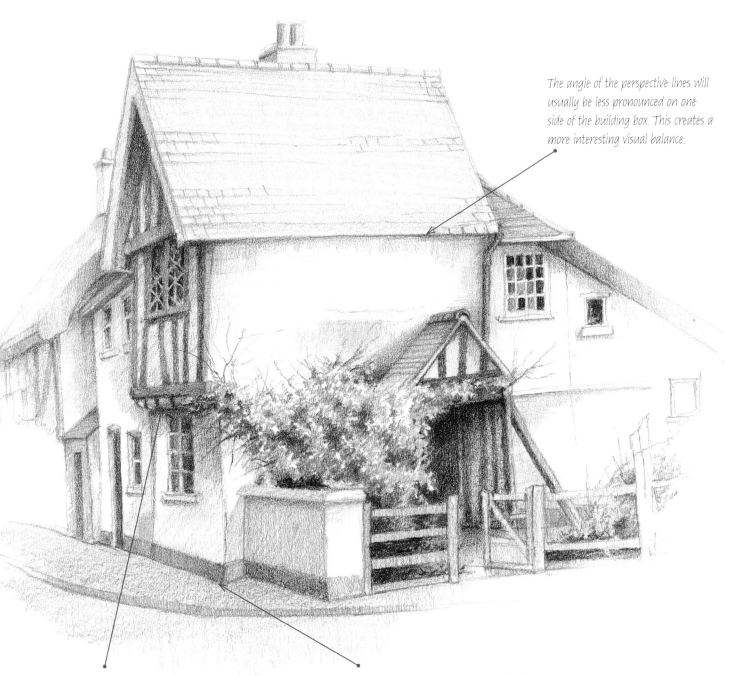

The angle of the perspective lines will usually be less pronounced on one side of the building box. This creates a more interesting visual balance.

The perspective box structure can be seen here as one box visually balanced on top of another to create the building.

The more intense angle of the perspective line will often be along the ground where building and pavement meet.

Three-point perspective

Three-point perspective is largely present in photographs taken with wideangle lenses – although we often see three-point perspective without fully realizing it. When we look along a road, we expect the buildings alongside to seem to converge towards the furthest end, with their respective heights appearing to diminish. We do not often look up at a two-storey house and see the building's walls appear to converge skywards. Taller buildings, however, will often seem to be narrower at the top than they are at the bottom. As this effect is often created in photography, we have a tendency to reject it as artists and straighten out the convergence. Three-point perspective can, however, add visual impact to your drawing that a corrected-perspective drawing may lack.

The first stage is to create a drawing, following the rules of two-point perspective. Once the basic outline is established, you can consider the angle of convergence that you wish to create in the height of your building. A very tall building will require the third vanishing point to be established high in the sky, whereas a smaller tower will require a lower vanishing point. Here lies your main dilemma. The higher the vertical point, the less the angle of convergence; the lower the point, the more dramatic the perspective will be. You may wish to distort the angle to create a particularly strong image, or you may wish to use this technique purely to suggest one individual tall building.

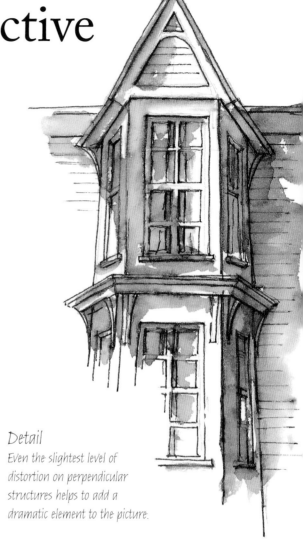

Detail
Even the slightest level of distortion on perpendicular structures helps to add a dramatic element to the picture.

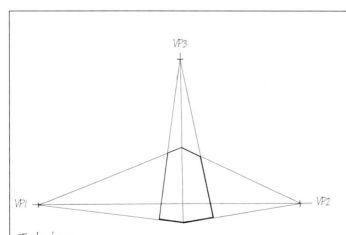

Technique
Tall buildings will need a third vanishing point (VP3) in order to create a sense of height. This is an artificial but valuable compositional device. Having decided how high your third vanishing point will be, simply proceed to draw the converging outer lines of the building. When you come to draw the windows, remember that they will still converge to the sides as well as to the top to gain the maximum impact.

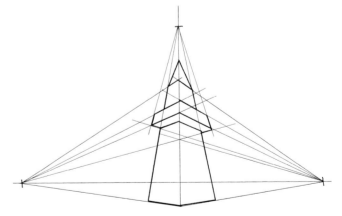

Structure
This construction system allows you to draw the underside of structures in perspective as you look up at them. The visual distortion is created by extending lines upwards to VP3.

North European bar/café

The unusual long, thin format of this drawing served to emphasize the slightly distorted perspective that, in this case, could not be avoided.

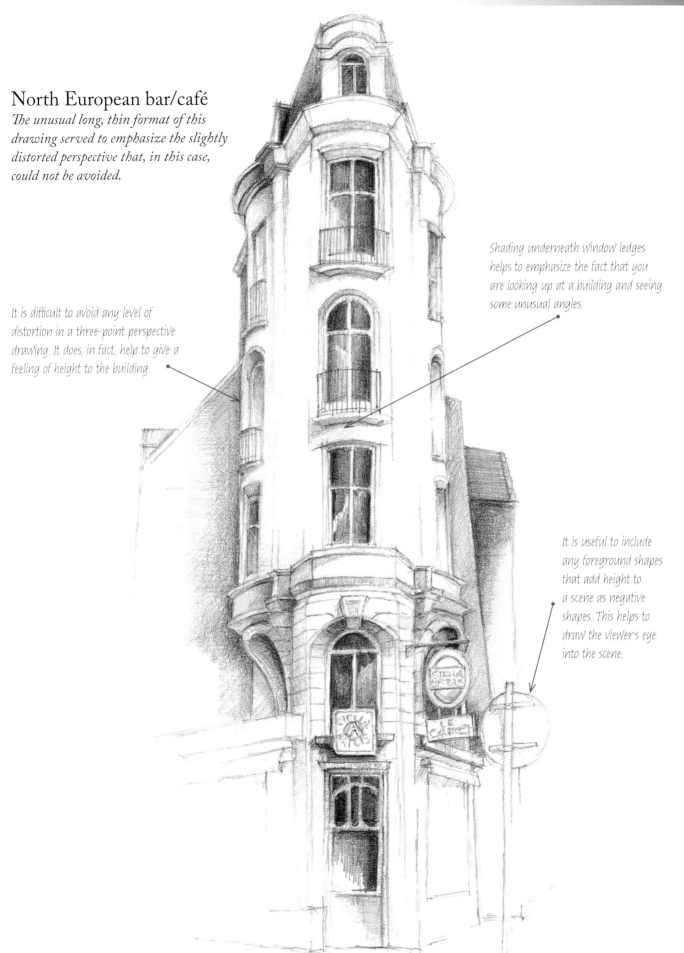

It is difficult to avoid any level of distortion in a three-point perspective drawing. It does, in fact, help to give a feeling of height to the building.

Shading underneath window ledges helps to emphasize the fact that you are looking up at a building and seeing some unusual angles.

It is useful to include any foreground shapes that add height to a scene as negative shapes. This helps to draw the viewer's eye into the scene.

Squaring up

Few of us go out on a sketching expedition armed with an A1 (23½ by 33-inch) drawing board and a selection of sheets of large paper. Apart from being difficult to carry, it is unlikely that we could spend the amount of time that such a large drawing would require in one sitting. The reality is that most of us go out with the intention of producing several sketches in an appropriately sized sketchbook. Occasionally we will be taken by a particular sight and be inspired to make an impromptu sketch on any sheet of paper we happen to have. These practices are good, and on-site sketching is to be actively encouraged. The problem, however, lies in what to do with your sketches once you get home.

 One answer is to use them for reference to create a larger, more detailed version of the original sketch. If the change of scale from thumbnail to A2 (16½ by 23½-inch) drawing is too intimidating, you might like to consider squaring up your drawing. This technique involves placing a regular grid on top of your original sketch. (If you don't wish to draw directly on to your sketch, you can always work on tracing paper.) Treat the next stage like a jigsaw puzzle, ensuring that all the sections match perfectly before you progress to shading and completion.

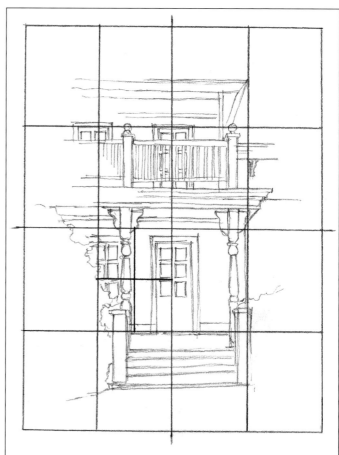

Technique

Your grid may have five vertical and five horizontal lines, creating a total of sixteen squares or rectangles. Now, draw exactly the same grid, but make it fit on to the large sheet by doubling or trebling the size of the spaces between the lines. Make sure that these lines are sketched lightly, as you will want to remove them eventually. You may find it easier to number each square or rectangle on the original before you start transferring the shapes in each particular section. A regular grid can be drawn on top of a simple outline drawing, or on to a sheet of tracing paper if you don't want to draw on to a favourite sketch.

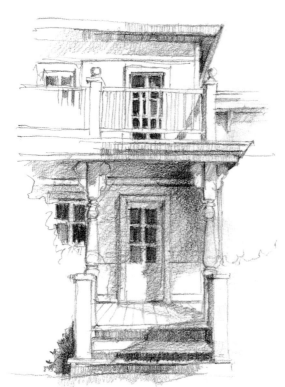

Thumbnail sketch

This initial thumbnail sketch was made to explore the way the shadows were cast across the wooden porch.

Kentucky wooden porch
A detailed drawing could be developed better on a larger scale. This grid helped to create a reliable scaled-up line drawing to build on to.

It is important to ensure that any sections touching the guidelines on the sketch touch the lines on the enlargement grid.

The rectangles can be subdivided to allow for a more detailed section enlargement.

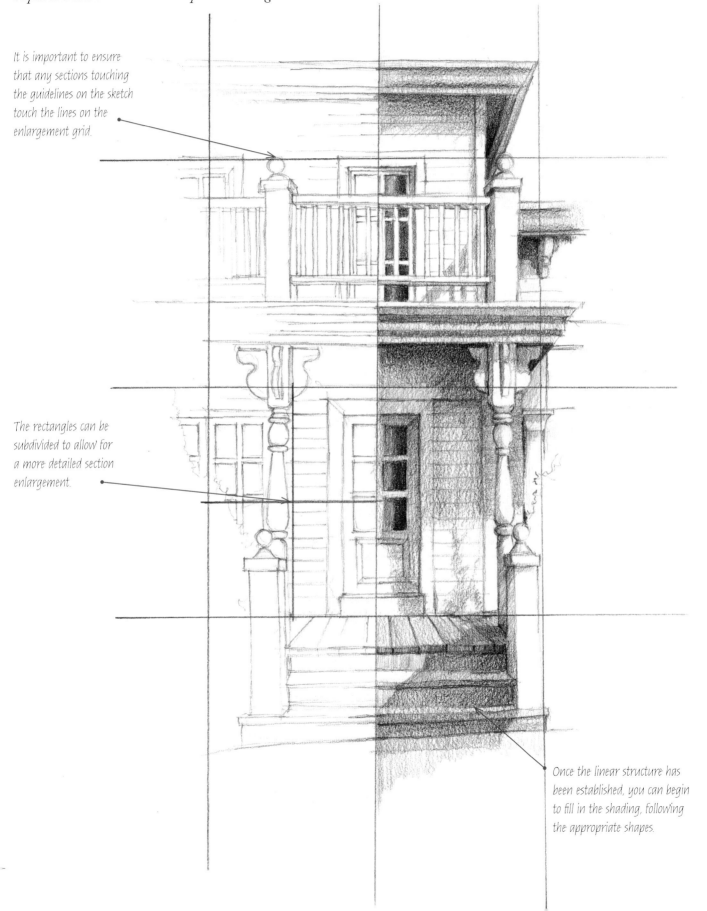

Once the linear structure has been established, you can begin to fill in the shading, following the appropriate shapes.

The rule of thirds

Being able to judge exactly where to position a building on a page for the best visual effect takes some time to learn, but you can try using a few key rules from the very beginning.

The main rule concerns dividing the page into thirds using the picture's compositional elements. This is a compositional technique that was developed in the 15th century and allows for the optimum visual dynamic. The key to making this work for you is to find the most central feature in your subject – for example, this could be a doorway, the apex of a roof, or a gateway – and line this up with one of the vertical thirds. Next, try to line up the horizon line, real or imaginary, along the bottom line. This should give you a good starting point for the most successful composition.

Try to avoid placing the centre of your composition in the geometric centre of the page, as this leaves the viewer's eye with nowhere to go. You will find that if you leave some space on either side of your building, you will let the viewer's eye travel through your composition, making looking at your drawing a much more interesting experience.

It is also worth considering the amount of space that you leave at the top and the bottom of your composition. Try not to create an imbalance – having too much sky and no space for a road or pavement, for example. This can have a disconcerting effect on the viewer; it may seem that your drawing is about to fall out of the picture frame because of the visual pressure from above.

Thumbnail sketch
A sketch made on a corner of a sheet of paper may need to be fine-tuned to make it into a composition.

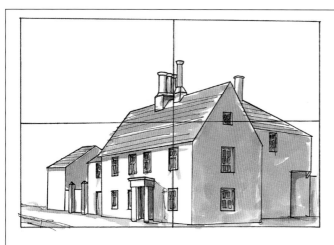

Technique
Dividing the building centrally, with the main chimneys in the centre of the paper, and positioning the building on the bottom, produces a bottom-heavy image with too much empty space on top.

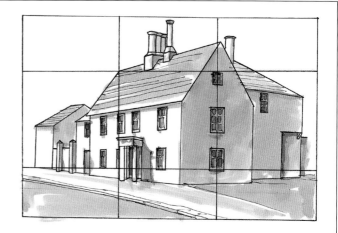

Technique
Positioning the invisible horizon along one third of the composition and the apex of the roof along the vertical third creates a more visually balanced picture.

Roadside house

The success of this composition relied upon experimentation. Don't just start in the middle and hope that the space around your building will work for you.

Including some sky can be useful to create mood and atmosphere. It also provides something to view a building against.

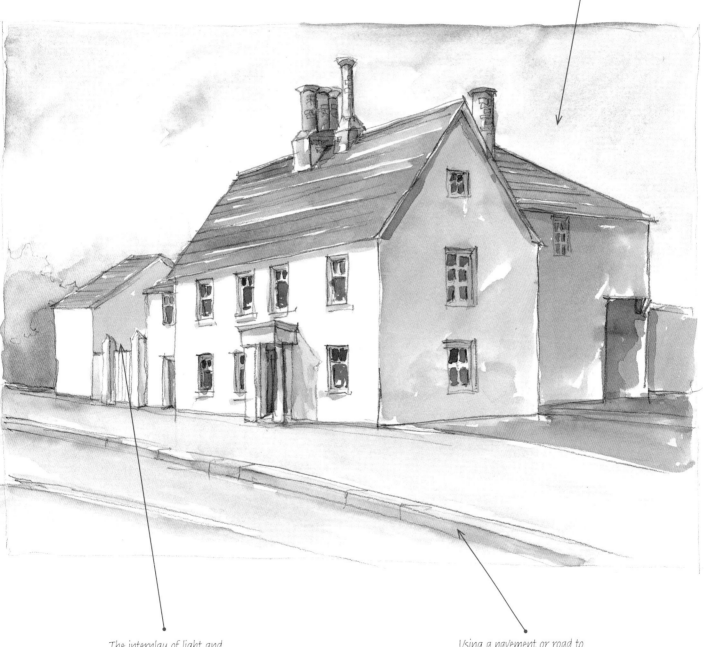

The interplay of light and shade enhances this drawing by adding contrast to the compositional balance.

Using a pavement or road to lead the viewer's eye into the composition is a useful device.

Foreground vs background

When you start to draw buildings, you will realize that they rarely exist in isolation; you will often find bollards, lamp-posts, trees, fire hydrants and all manner of other obstructions in your way. The first question you need to address is how important they are to the picture you want to draw. If the answer is 'not very', then leave them out completely. This is the advantage artists enjoy over photographers – you can choose exactly what you put in your picture. If, however, the object is important to the success of the picture, draw it in ready for the next decision. This is whether you draw the shape as a positive, fully shaded object, or whether you leave the skeletal outline as a negative shape. Both methods are worthy of consideration.

Positive shapes have the effect of dominating the foreground. This means that they will appear to push your building into the middle ground, where it will no longer be the centre of attention. If the object is important to the composition, such as a lamp-post outside a busy shopping area, then this is fine.

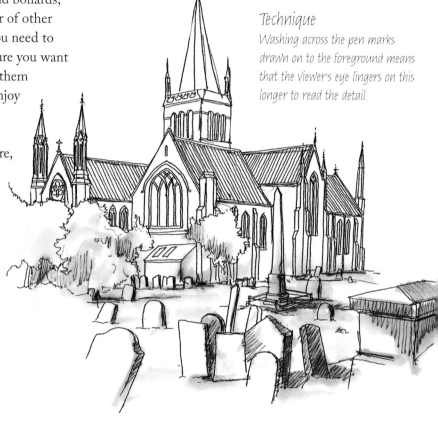

Technique
Washing across the pen marks drawn on to the foreground means that the viewer's eye lingers on this longer to read the detail.

If, however, you choose to leave the shapes unshaded, the viewer's eye will be drawn to the central building, bypassing the ghostly white shapes that take up some space in the front of the building.

This interplay of light and dark shapes in front of your subject is certainly something to experiment with, as you can create some exciting visual dynamics – especially with trees and their branches. Looking through the skeletal twigs of a winter tree set against the dark tones of a shaded building can produce a fascinating push–pull effect on the eyes – and anything that makes a picture more intriguing must be good!

Technique
By leaving the foreground as a set of negative shapes, the church becomes the visual focus.

Main Street, USA

The tree in this drawing was important to the scene, but not vital to the shop front. For this reason I drew it as a negative shape, focusing on the building instead.

Strength of tone or shading behind a negative shape is important in order to make it work visually.

Negative shapes often benefit from detailed observation of intricate detail.

A compositional device that involves using more than one negative shape has been used here.

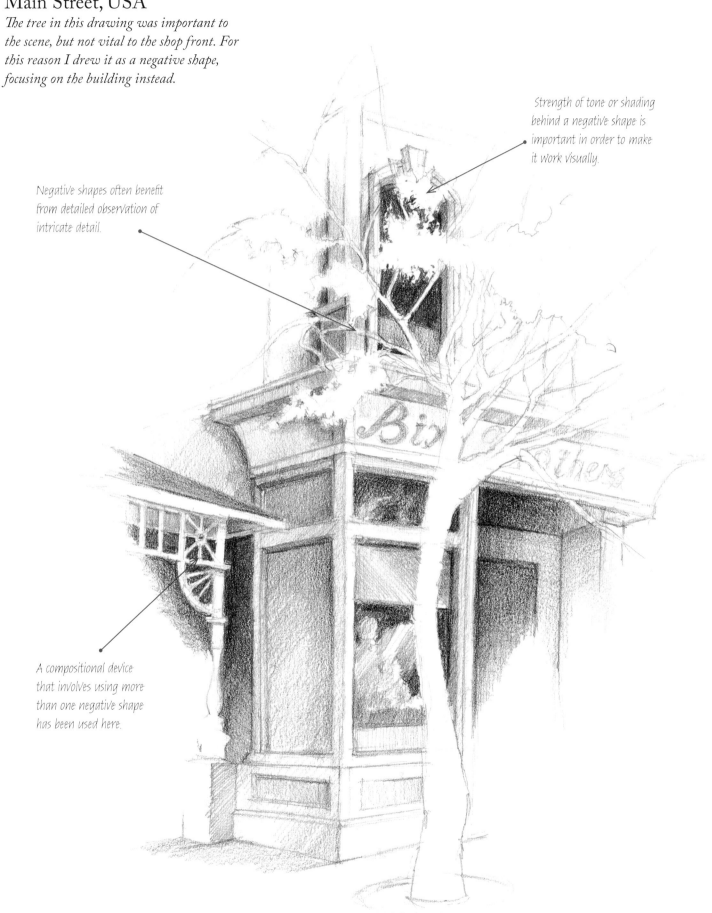

Brickwork

Bricks usually appear in a regimented pattern: even when they are used for decoration, they are generally arranged symmetrically. Most brick buildings also feature different coloured bricks, such as burnt or blue-black bricks, in any one section. These bricks can help to break up the visual plainness of a large expanse of brickwork – pick them out them with your chosen media to emphasize that they stand out.

You will rarely be able to draw every brick that you see in a wall – indeed, this is neither possible nor desirable. Instead, suggest brickwork by drawing small sections of brick – usually clusters of four or five bricks spread across two or three rows. Make sure that the gaps between these clusters are uneven, or it will look as if the bricks have been positioned to form a decorative pattern.

The last big decision that you need to make is about positive and negative bricks. As you look along a row of bricks, you will often find that the cement holding the bricks together is, in some places, darker than one or two of the bricks. In this case, you can create negative brick shapes. This technique involves either leaving the selected bricks with just the first layer of toning (you will usually add a second layer of either paint or pencil to darken the tone of most bricks), or not shading them at all if you are suggesting a small cluster. The effects of positive and negative painting are varied and it is worth experimenting.

Using all these techniques can bring an artwork to life: odd bricks can be picked out for emphasis; negative bricks add a sense of contrast; and small clusters of suggested bricks should give you the effect of a very good brick wall.

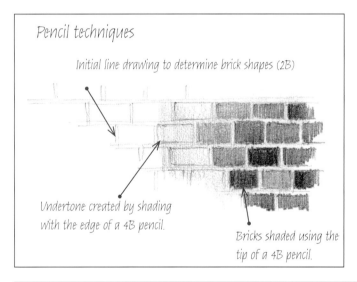

Pencil techniques

Initial line drawing to determine brick shapes (2B)

Undertone created by shading with the edge of a 4B pencil.

Bricks shaded using the tip of a 4B pencil.

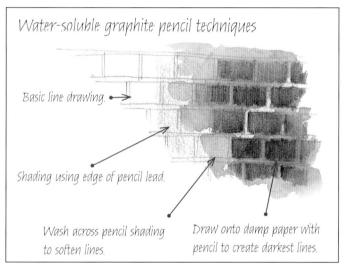

Water-soluble graphite pencil techniques

Basic line drawing.

Shading using edge of pencil lead.

Wash across pencil shading to soften lines.

Draw onto damp paper with pencil to create darkest lines.

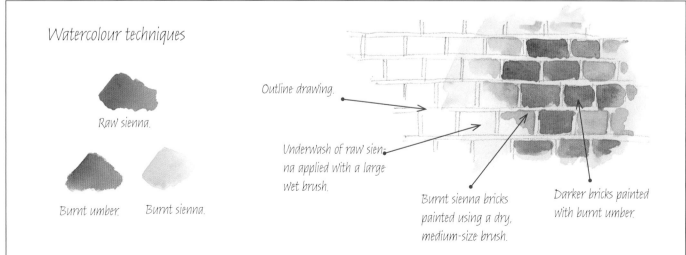

Watercolour techniques

Raw sienna.

Burnt umber. Burnt sienna.

Outline drawing.

Underwash of raw sienna applied with a large wet brush.

Burnt sienna bricks painted using a dry, medium-size brush.

Darker bricks painted with burnt umber.

Brick townhouse
It would not be advisable to try to draw every brick in a building. To create a good drawing, you just need to select a few bricks to suggest the fabric of the building.

Specific features such as window surrounds can be drawn in full to emphasize the particular character of a building.

Negative shapes can also be used to help suggest rows of brickwork.

Select small batches of bricks (roughly three lines or rows) and draw these as positive shapes.

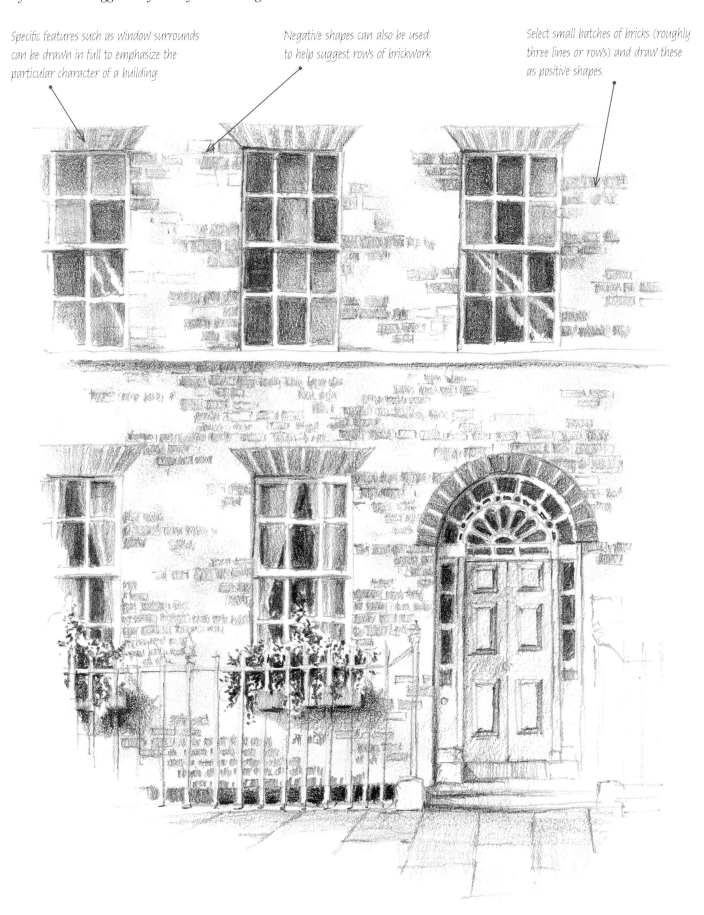

Stonework

Unlike brickwork, stonework is often set in an apparently random manner, rarely following any standard pattern. One common characteristic, however, is the contrast to be found between large stones and small stones. This makes many stone walls visually appealing. It also raises a key difference in the techniques used for drawing brick and stone walls. The uniform size of bricks means that you have to suggest rather than draw every one. Stones, however, are irregular in size and shape, so you can draw a much greater number of stones in a wall without visually cluttering your drawing.

Another difference between brick and stone is that stone walls can take on a relief appearance as some stones protrude from the wall, casting a slight shadow. It can

be helpful to leave these stones as negative shapes and use the shading to the side or underneath to push them forward visually so they look as if they are sticking out from the wall. Details commonly found in stonework can be attractive to depict and it is a good use of time to make studies of these details for future reference.

The other main difference between brick and stone walls is that stones are not always cemented together. Sometimes you will find that stone walls have been constructed with only a few paper-thin gaps around each stone. In this case, you will have to ensure that you keep the shading on the stones quite light, and save the darkest tones for the spaces surrounding them. This will give a feeling of depth and solidity to your work.

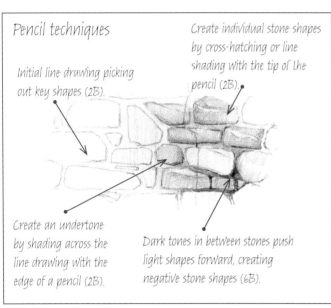

Pencil techniques

Initial line drawing picking out key shapes (2B).

Create individual stone shapes by cross-hatching or line shading with the tip of the pencil (2B).

Create an undertone by shading across the line drawing with the edge of a pencil (2B).

Dark tones in between stones push light shapes forward, creating negative stone shapes (6B).

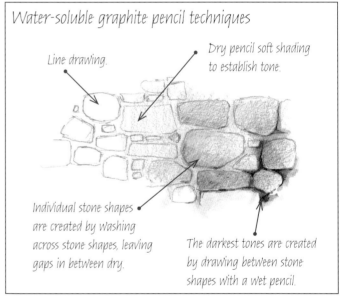

Water-soluble graphite pencil techniques

Line drawing.

Dry pencil soft shading to establish tone.

Individual stone shapes are created by washing across stone shapes, leaving gaps in between dry.

The darkest tones are created by drawing between stone shapes with a wet pencil.

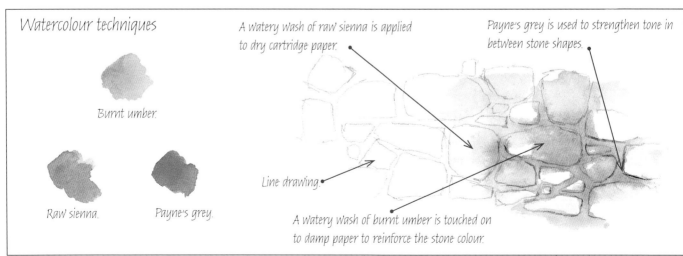

Watercolour techniques

Burnt umber.

Raw sienna.

Payne's grey.

A watery wash of raw sienna is applied to dry cartridge paper.

Payne's grey is used to strengthen tone in between stone shapes.

Line drawing.

A watery wash of burnt umber is touched on to damp paper to reinforce the stone colour.

Cornish stone cottage

Although maybe not a conventional home, this stone cottage has been improved by the addition of a windowed terrace. The patterns created by the stone, however, are the most appealing feature.

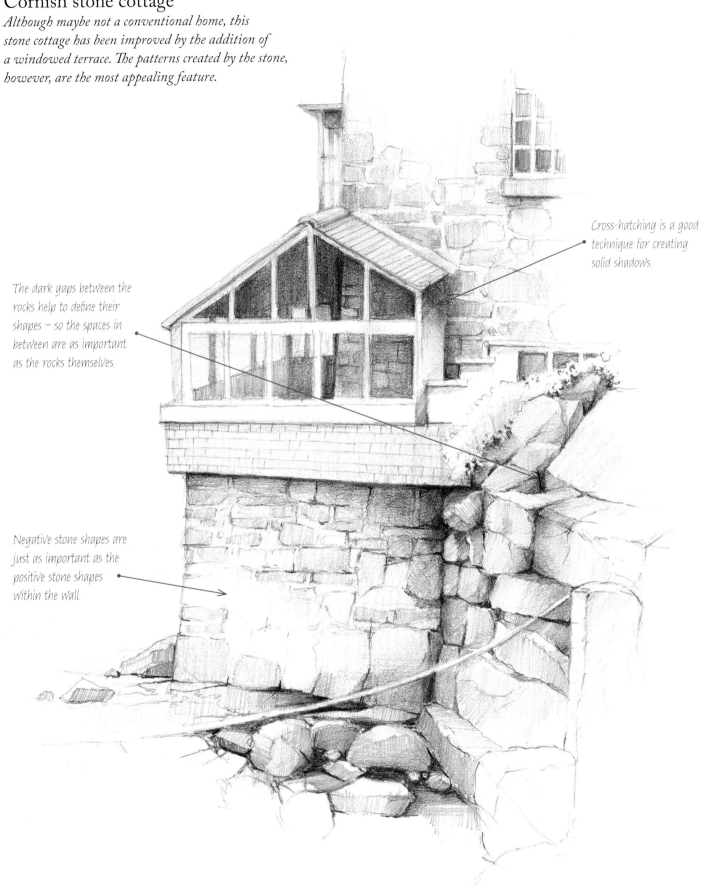

Cross-hatching is a good technique for creating solid shadows.

The dark gaps between the rocks help to define their shapes – so the spaces in between are as important as the rocks themselves.

Negative stone shapes are just as important as the positive stone shapes within the wall.

Wood

The most common type of wood construction to be seen on the outside of buildings is weatherboarding or clapperboarding. This uses the same principle as clinker boat building, whereby the lower plank is attached to a frame, just underneath the upper plank, and slightly angled. This prevents water running down the walls and in between any gaps in the wood. As artists, we are helped considerably by this building technique, as every plank of wood casts a shadow onto the plank directly below it. As the planks are angled, this shadow will often be graduated (dark at the top and gradually softening towards the bottom).

This method of building has become traditionally linked with American small towns, where some of the most attractive whitewashed, wood-clad buildings are to be found. From the artist's point of view, whitewashed buildings open up a whole host of possibilities for an assortment of media.

Liquid media are always useful for drawing white buildings (you can very easily pull a wash across a wall to quickly create a light tint), but they are certainly not the only media that you can use. The side of the lead of a 4B pencil will do just as well to shade the softness of a whitewashed wall caught in shadow. Once the shading is established, you can then work on the wood, shading under the planks. Of course, if the wall or building is too large, you can always just suggest some of the planks. It is always important to consider just how much detail you are going to leave in or edit out; making a small study before starting a painting will give you a good idea of how much detail is appropriate.

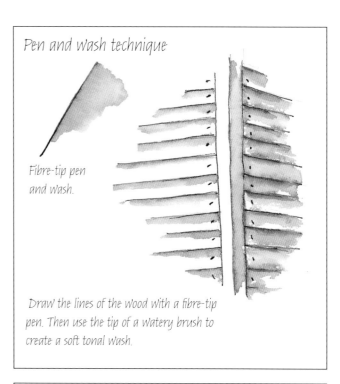

Pen and wash technique

Fibre-tip pen and wash.

Draw the lines of the wood with a fibre-tip pen. Then use the tip of a watery brush to create a soft tonal wash.

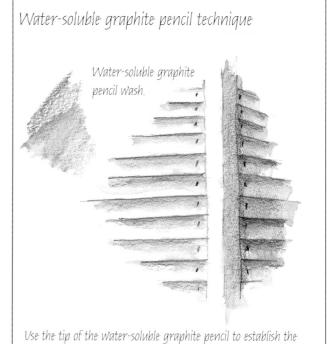

Water-soluble graphite pencil technique

Water-soluble graphite pencil wash.

Use the tip of the water-soluble graphite pencil to establish the structure of the planking, then run a damp brush underneath each line and pull it downwards.

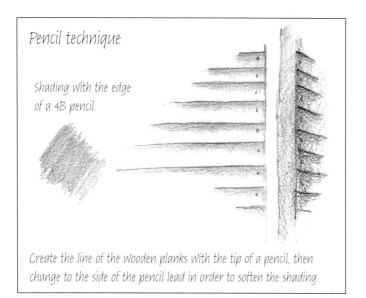

Pencil technique

Shading with the edge of a 4B pencil.

Create the line of the wooden planks with the tip of a pencil, then change to the side of the pencil lead in order to soften the shading.

Timber-framed cottages

I chose a particularly low viewpoint to draw this row of wooden cottages to emphasize the angles of the roofs and to slightly exaggerate their height.

The timber cladding is the key feature here, but you need not draw every plank. Suggestion is the key to a fuss-free drawing.

Always ensure that the timber planks follow the perspective lines established for the basic structure of the outer building framework.

Shading inside inset windows is important to prevent a flat, cardboard cut-out look to the side of the building.

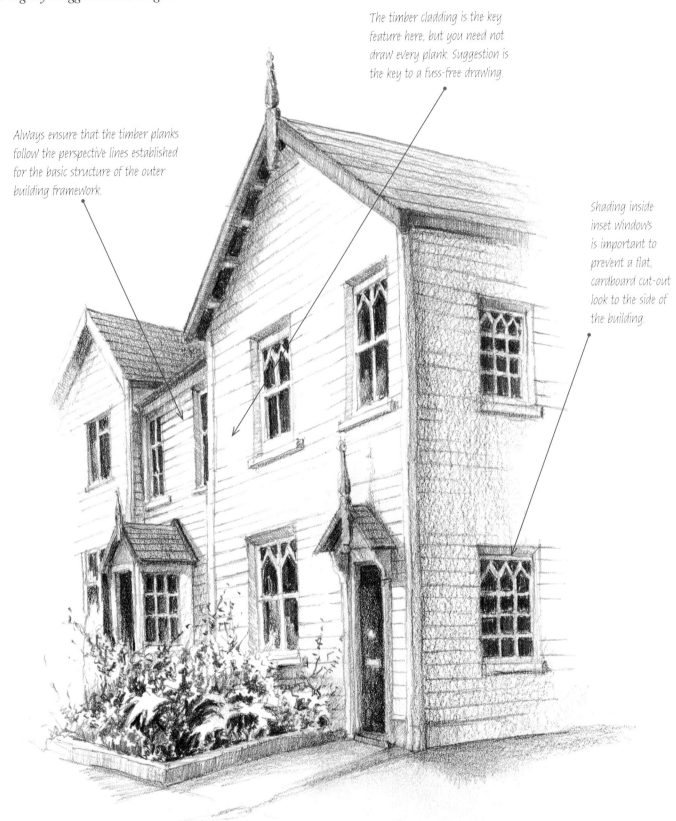

Tiles

Tiles are often one of the most attractive parts of a building. They can be especially characteristic in Mediterranean countries, where pan-tiled roofs glow in their natural ochres and siennas. The only problem is that we rarely see tiles at their best, unless we can gain a privileged view across a set of rooftops. More often than not, however, we have to look up at roof tiles when we are drawing them.

Flat roof tiles are best drawn in the same way as wood; they overlap each other, so each row of tiles will cast a shadow down on to the row below. For large roofs, simply suggest some of the rows of tiles as they run along the length of the roof.

Pan-tiles (the more decorative, curved tiles) offer considerably more for the artist to observe and record. As these tiles overlap not just from top to bottom, but also from side to side, a whole new wave of pattern and shape is created by the rise and fall of the tiles in their lines. The top part of the tile will usually be caught by the light, while the lower part is caught by the shadow of the next tile, and so on. This provides an ideal subject with which to practise graduated shading, as the light rolls in waves across the tiles.

Tiles are also highly conducive to watercolour washes. The warm-coloured clay tiles have often been made from the earth that offers up the natural sienna and ochre colour pigments. They are, therefore, ideal for recording with burnt sienna paint. The best effect and the strongest colours will be achieved by laying a raw sienna wash on top of your line drawing and then applying a wash of burnt sienna on top. The translucency of the watercolour paint allows the two colours to work together to produce a rich, warm glow.

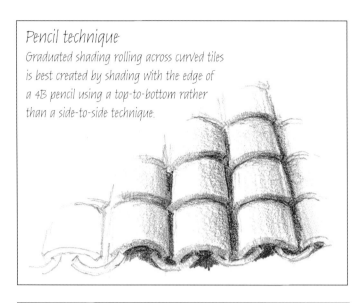

Pencil technique
Graduated shading rolling across curved tiles is best created by shading with the edge of a 4B pencil using a top-to-bottom rather than a side-to-side technique.

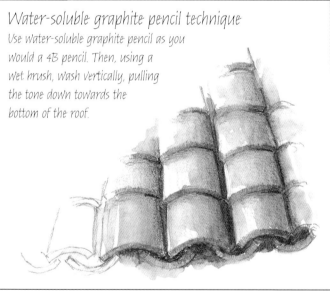

Water-soluble graphite pencil technique
Use water-soluble graphite pencil as you would a 4B pencil. Then, using a wet brush, wash vertically, pulling the tone down towards the bottom of the roof.

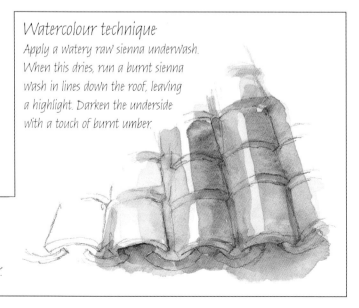

Watercolour technique
Apply a watery raw sienna underwash. When this dries, run a burnt sienna wash in lines down the roof, leaving a highlight. Darken the underside with a touch of burnt umber.

Raw sienna. Burnt sienna. Burnt umber.

Rooftop view

The lack of any apparent order was the main appeal of this scene; random selection is often of interest to artists of any persuasion, but especially to those who draw structures.

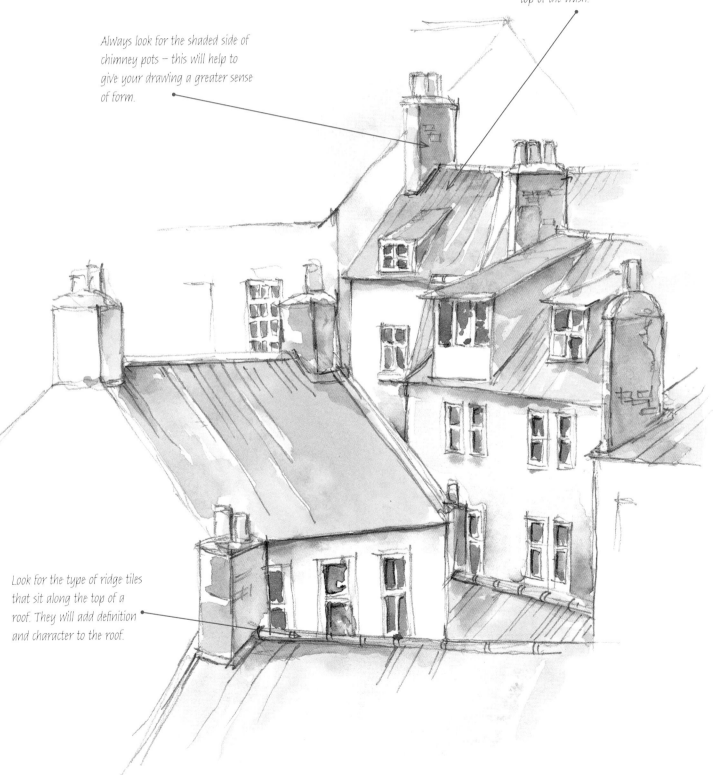

The line of the tiles can be indicated with a few suggestion lines drawn quickly on top of the wash.

Always look for the shaded side of chimney pots – this will help to give your drawing a greater sense of form.

Look for the type of ridge tiles that sit along the top of a roof. They will add definition and character to the roof.

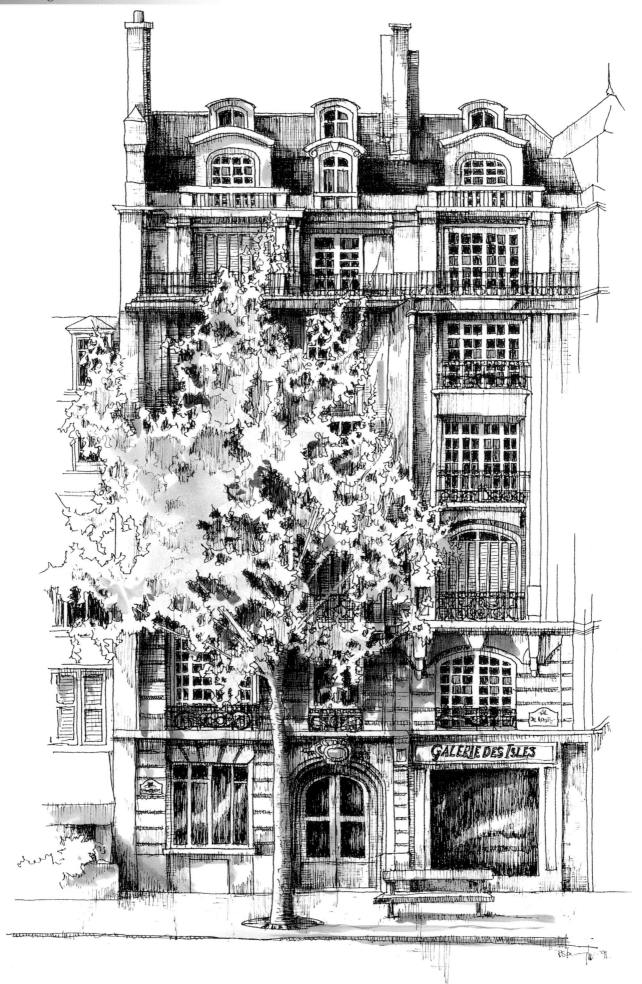

THE BUILT ENVIRONMENT

In the opening chapter of this book, I referred to the fact that the historical importance and civic heritage of buildings should not be ignored. You don't have to study the origins of buildings, and you certainly don't need to know the finer points of architecture, to draw buildings. However, there is usually a good reason why buildings look the way they do. Fashionable designs spread quickly, and are copied and developed over the years, with regional variations growing according to the availability of local materials. This knowledge may be useful for certain locations; for example, clapperboarding in New England, USA, stonework in Yorkshire in the north of England, or art nouveau features in Belgium.

The built environment, however, need not be restricted to buildings. Of all subjects for sketching, some of my personal favourites are French enamel street signs. Would any sketch made in the centre of New York look right without a yellow cab? Similarly, a scene of a European street café without any human life would simply not work. So it is important that you take an overview of the site in which you are sketching, and be prepared to draw some of the visual peripherals. These will often help to set the scene, even though the building you are drawing will still hold centre stage.

On a practical note, you will not need to follow the example of many weekend painters who head off for the great outdoors laden with collapsible easels, stools and backpacks full of paints. You can draw a sketch at a bus stop, in your car, or on many of the public seats to be found in the larger villages, towns and cities. You will not need bags of equipment, as most of it will fit into a reasonable-sized jacket pocket. Also, unlike your country-painting colleagues, you can remain anonymous – a sketchpad and a pen or pencil rarely attracts onlookers, allowing you to draw in relative peace.

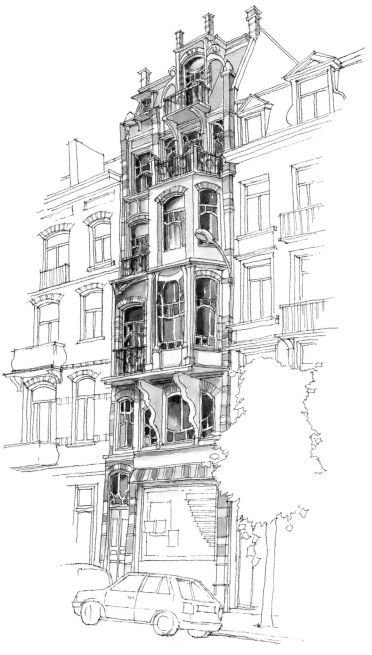

RURAL BUILDINGS

For many artists, the ideal day would involve spending a few hours sketching outside a row of gentle thatched cottages with whitewashed walls, picket fences, roses rambling around the door, and a cat slumped lazily across the doorstep. Such places probably do exist, but more often in a fantasy world of times long since passed.

The reality is that many rural buildings will often have a practical purpose; farms, mills and even fishermen's cottages are all functional buildings, so be prepared to include some of these elements.

The main consideration when sketching rural buildings is the material from which they have been constructed. Stone has always been a popular building material in rural communities because of its ready availability and cheapness. Timber-framed buildings are also commonly found. Both of these require different treatments, using different drawing techniques, all of which are explained and explored in the following pages.

One important point to consider before heading out to sketch in the rural environment is that many old buildings were constructed from inexpensive materials. Some were even an early example of recycling – many timber-framed buildings, for example, were made using the timbers from decommissioned ships. Many were built to house rural workers, and have survived because of their stark simplicity – but they may not have survived fully intact. Lack of proper foundations, combined with the use of untreated timbers, has resulted in many rural buildings developing worrying twists and turns in their structural appearance. This adds to their visual appeal, but can look awkward or unnatural in your drawing. Pay special attention, therefore, to the way in which you draw the elements that will appear to secure your buildings firmly on to the ground – doorsteps and shadows are possibly more important when depicting rural buildings than in any other type of building covered here.

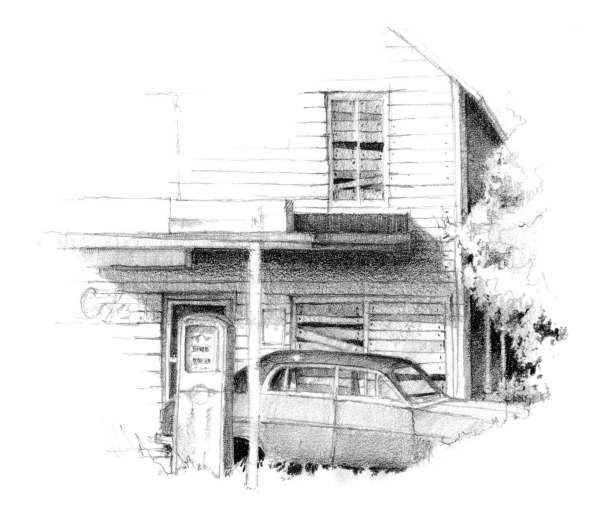

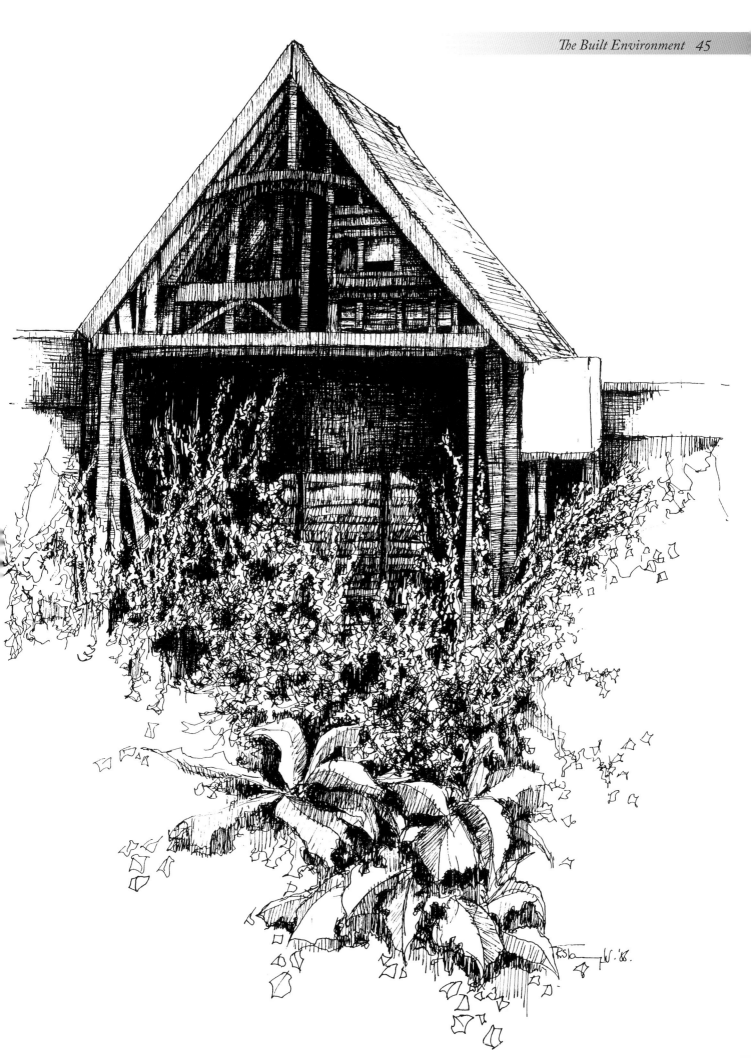

Cottages

The appeal of most cottages usually lies in their simplicity. Built for the poorest in society, or at best for artisans and craftspeople, these buildings were made from the most basic materials; many are now twisted and bent by the years. However, that is also what makes them so different from the corporate buildings of the average town centre.

I like to look for particular features when drawing old cottages – usually the windows, doorways and roofs. The window and door frames are sometimes set at unusual angles where the wall has buckled, or are set deep in old stone. In these instances, pay special attention to the wooden frame surrounds. You may find that it helps to sketch lightly around these with the edge of your pencil lead, and then use the tip in order to define the shapes of the stones, brickwork or plasterwork. You can help to make these facets look three-dimensional by emphasizing any shadows underneath window ledges or doorsteps.

Chimney pots and stacks often appear to be rickety structures with some unusual shapes contained within them. Don't be afraid to draw these at odd angles, even if they appear to be defying gravity, and don't forget to draw any shadows that they cast on to walls or rooftops. This will help to anchor the chimney visually to the actual buildings, preventing it from looking like a cardboard cut-out. Similarly, if the entire cottage is set at an unlikely-looking angle, make sure that you draw the shadow cast on to the ground to make it appear a little more secure.

Structure

This whitewashed fisherman's cottage offered no texture. Its key features had to be defined purely by shading with the edge of a soft pencil lead.

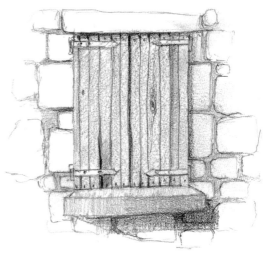

Detail

The combination of textures allowed this study to become a vehicle for my 6B pencil. Lines were drawn with the tip and shading was created with the side of the lead.

Rickety cottage

The rickety appearance of this simple cottage made it a fascinating subject. Few lines were straight and most features overlapped, creating a wealth of varying shadows.

Use directional lines to indicate where vertical and horizontal blocks meet.

The lines of roofs (and often walls) in old cottages are rarely straight. Don't be afraid to let your pencil wobble along with the line of the building.

Overhanging eaves are a common feature of old cottages. This is where you will usually find the darkest shadows.

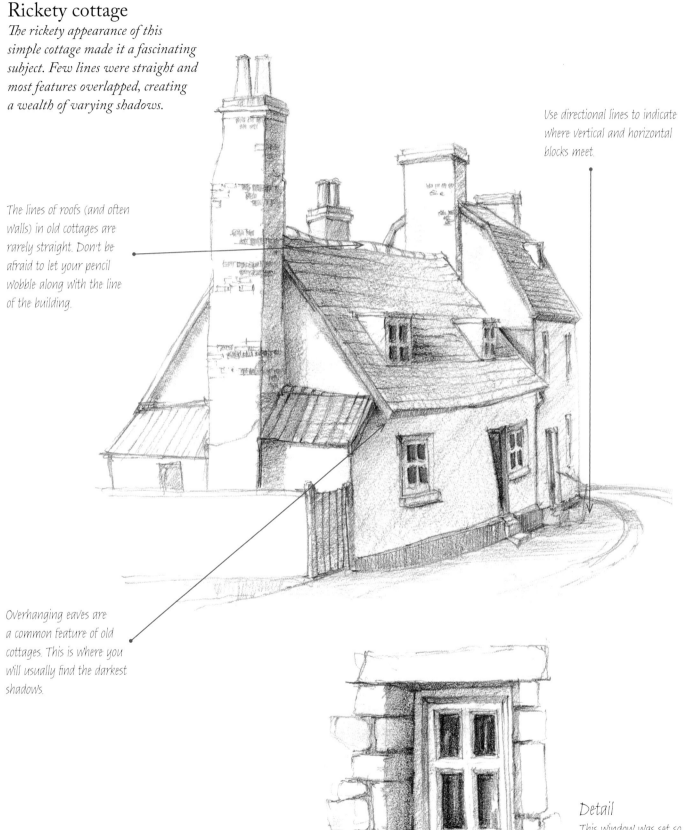

Detail

This window was set so far into the stone wall that it allowed some real depth to be created by shading.

Huts and barns

Much like cottages, barns are functional buildings, constructed from the most basic of materials. The key difference is that they can still be used when they are in a much more run-down state, offering us a wealth of opportunity to draw the textures created by years of exposure to the weather. For this reason, I sometimes introduce watercolour into my drawings of barns. This allows a much more immediate solution to creating an image of textured stone, wood or rusting metal.

The use of a water-based medium will allow you to wash a colour across a line drawing. This alone will give your drawing a new dimension. Before the first wash dries, however, you can add another wet colour. The wet colour will bleed into the damp paper and will dry with a soft edge, giving the effect of damp plaster, rotting wood, or rust stains, depending on your choice of subject and colour. Once this process is complete (you can repeat it as many times as you wish) and the paper has dried thoroughly, you can then return to the drawing process. You may wish to reinforce any pencil lines that have become diffused by the addition of watercolour paint, and then move on to drawing more detail with a pencil or pen. You may, however, wish to draw in some particular details with a small paintbrush, for example, picking out a few individual bricks or stones. Of course, you could include any of these techniques in your drawing – there are no hard and fast rules!

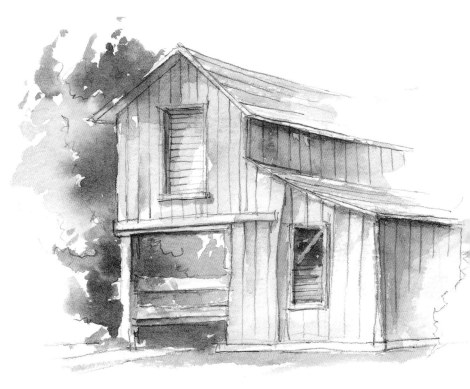

Thumbnail sketch
This sketch of an old wooden barn was made to explore its context. How did it interact with the background? Was the building lighter or darker than the trees?

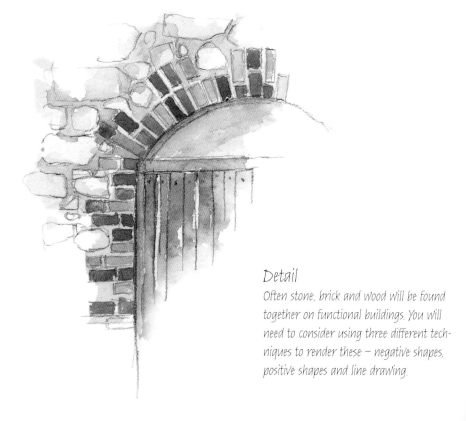

Detail
Often stone, brick and wood will be found together on functional buildings. You will need to consider using three different techniques to render these – negative shapes, positive shapes and line drawing.

Artisan's barn

This picture is a combination of techniques – roughly half drawing and half colour wash. Neither technique would have worked particularly well without the other.

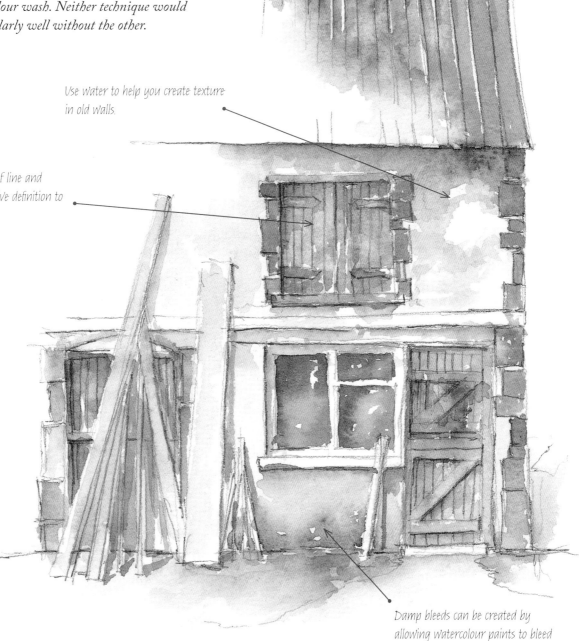

Use water to help you create texture in old walls.

A combination of line and wash helps to give definition to building fabrics.

Colours used

Raw sienna.

Burnt umber.

Burnt sienna.

French ultramarine.

Damp bleeds can be created by allowing watercolour paints to bleed by themselves.

Technique

Rust effects are best created by drawing on to strong paper, applying a lot of water, and allowing the colours to run and bleed into each other.

Mill buildings

The one thing that most mill buildings have in common is curves. Even if the building housing the mill workings is not round, you will almost certainly find curved surfaces somewhere within its structure.

These buildings provide an ideal opportunity to practise graduated shading and really explore the tones that you can create with graphite pencils. You will sometimes be able to see the curved lines of stone or brick within the body of the mill building. Take care not to exaggerate this; a few suggested lines of material with just a slight curve towards the outer edges of the building will suffice.

Detail
The main focus of this study was the contrast between the curves of the mill wheel and the sharp angles of the building. Opposing features often make for a more interesting composition.

Technique
The curves on this building were created by concentrating on the line of the roof and reinforcing this with graduated shading. This is best developed using two pencils that are similar in grade, yet different enough to show. The tonal difference between a 2B and 4B is ideal. Start by gently shading across the building from the light side to the dark side, keeping an even pressure until you reach the darkest edge; here, increase the pressure to achieve a darker tone. Then reverse the process with a softer pencil. Start at the darkest side, applying some pressure to your pencil, easing off as you work towards the lighter side.

Suffolk mill

The variety of shapes and tones were the main appeal of this mill. The outbuildings even held a certain charm with their odd and irregularly shaped roofs and small windows.

Highlights are always important. The white wooden structure needs to shine in order to stand out against the grey of the mill.

The main bulk of this building was shaded with the edge of a 4B pencil. This creates a more textural effect on cartridge paper.

The deepest shadows were created here using the tip of an 8B pencil. This allows some very dark sections to contrast with the white supports.

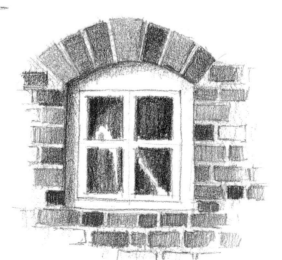

Detail

Small windows are common features in mills. The surround will often reflect the circular structure. I like to explore any brickwork around the window frame in pencil: this helps me to achieve the granular appearance of brick.

PROJECT: Timber-framed houses

Timber-framed buildings seem to have more oddities, angles, textures, and twists and turns than most other types of building. For this reason, it is always wise to embark upon a series of sketches before undertaking a major drawing of timber-framed buildings. The construction of wooden structures is critical; always look for the joints and make some preliminary sketches. Which timbers are the largest, which are the deepest?

All of these questions can be assessed through critical examination of a few small sections of your chosen building. This also gives you the opportunity to explore your chosen media. Which colours will you need? Is the wood always brown? How will you apply the colours? Making detailed studies will allow you to decide how much colour to use in a certain mixture, as well as how much paint to apply to the paper.

I like to use the full range of natural earth colours for these buildings. Raw sienna, a soft mustard-like colour, is my choice for creating an underwash for both brick and wood. These buildings rarely glow with radiant colour as they have usually been exposed to the elements for centuries. For this reason, I tend to moderate the colours by introducing a touch of Payne's grey. This is a mixture of blue and black paint; the black has the effect of removing any brightness from a mixture. Use this in moderation, because too much can completely flatten any colour to which it is added.

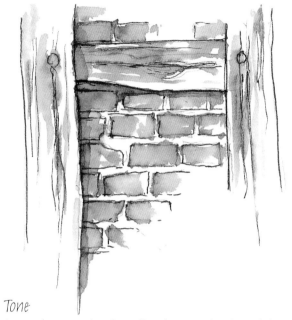

Tone
A monochrome study using a fibre-tip pen and wash can help you to gain a feeling of the tonal balance required. Ask yourself which is darkest – the wood or the brick?

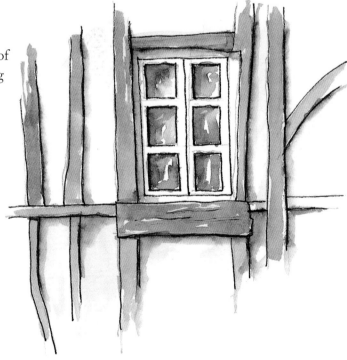

Colours used

Raw sienna. *Burnt umber.*

Burnt sienna. *Payne's grey.*

Detail
Make studies of interesting features such as doors and windows to inform your main drawing more fully. These sections will look small in the finished work, but are vital to its success.

Detail

Making a detailed examination of a small section of the timber structures will help you to gain a clear understanding of the relief shading that is a characteristic feature of such buildings.

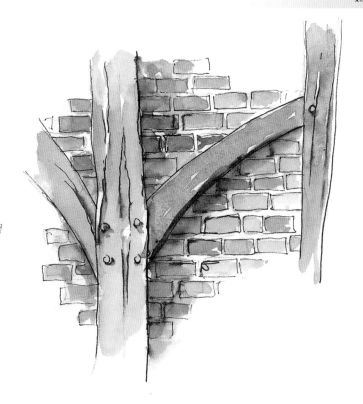

Structure

I sometimes find it helpful to establish the main areas of light and shade within a composition before I add any colour. To achieve this, I will usually complete a line drawing including as much information as is necessary to make the building look structurally correct. Then, either using a fibre-tip pen for the bleed, or a very diluted Indian ink wash, I will block in the main areas of shadow or dark materials. These can best be seen by closing one eye and squinting through the other. This has the effect of partially reducing your vision to tone rather than full colour, and allows you to concentrate on the area of shade. The initial outline drawing is crucial, as the next stage hangs on it. The good thing is that old buildings like this tend to be so uneven in appearance that a few wobbly lines go unnoticed.

PROJECT: *continued*

Once you have blocked these areas into your picture, you can mix the paints you have chosen from your preliminary studies and begin to tint your drawing. This should not be a lengthy process: certainly do not try to paint a picture. Your line drawing will already have established the structure and the details, and the three-dimensional form of your drawing will have been created through the initial use of tone. Therefore, feel free to wash paint on to your drawing simply to add colour.

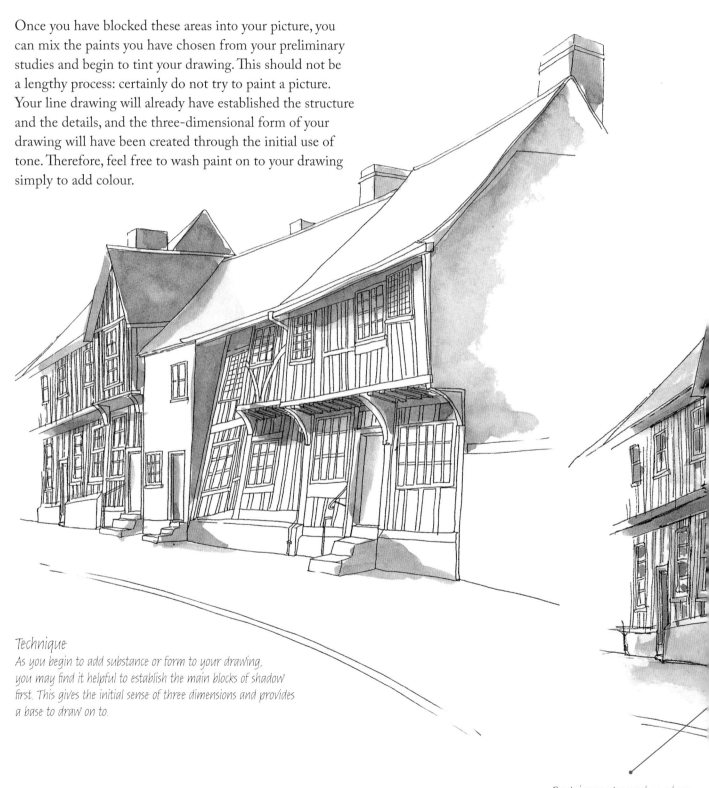

Technique
As you begin to add substance or form to your drawing, you may find it helpful to establish the main blocks of shadow first. This gives the initial sense of three dimensions and provides a base to draw on to.

Raw sienna was used as a base colour. Other colours were added on top to build up tones.

The finished picture

Buildings like these are highly conducive to loose wash techniques; this enhances their considerable character.

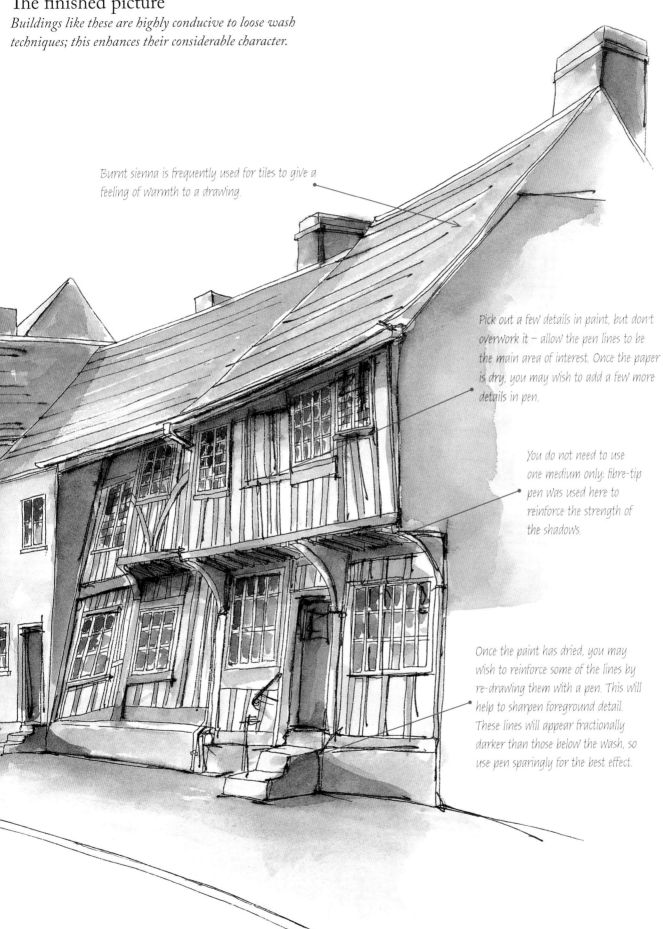

Burnt sienna is frequently used for tiles to give a feeling of warmth to a drawing.

Pick out a few details in paint, but don't overwork it – allow the pen lines to be the main area of interest. Once the paper is dry, you may wish to add a few more details in pen.

You do not need to use one medium only; fibre-tip pen was used here to reinforce the strength of the shadows.

Once the paint has dried, you may wish to reinforce some of the lines by re-drawing them with a pen. This will help to sharpen foreground detail. These lines will appear fractionally darker than those below the wash, so use pen sparingly for the best effect.

URBAN BUILDINGS

We often harbour thoughts of the urban environment as consisting of dark, grime-stained industrial districts, devoid of character and uninspiring to artists.

Whilst some locations do indeed have these qualities, many urban districts, such as old town centres, city centres and commercial districts in particular, have a diverse, culturally rich collection of buildings, constructed in a variety of styles for a variety of purposes.

One of the most appealing of these, in my opinion, is the townhouse. These are to be found in the older districts of towns and cities across the world, and share some common characteristics. Perspective will always be a consideration in drawing, as these buildings are often constructed of three or four storeys, including a basement. They will usually be of a symmetrical design and, as they were built to celebrate the wealth of their original owners, often display decorative brickwork around the windows and doorways. Drawing these buildings requires close

observation, and just the individual features alone can provide several pages of sketchbook studies.

Cafés, bars and restaurants are very much a part of the urban environment, providing a much-needed service for the workers and residents. These buildings serve a different purpose from the residential townhouses and also require a different method of drawing. The primary difference is in their construction; they tend to feature large areas of glass to encourage potential customers to look inside.

The urban environment may well be busier, noisier and sometimes grubbier than rural areas, but this is no excuse for not drawing within it. The cultural diversity of a community can be seen within its urban buildings, and this deserves to be recorded. The buildings may be more cramped than their rural counterparts, and you may need to call upon your perspective skills to record the terraces and imposing heights of structures that are so much a part of the urban environment.

Detached townhouse

For centuries, large towns and cities have been the playgrounds of the wealthy. Their money has allowed them to indulge in personal pleasures, including their houses. As a result, you will find many highly decorated and beautifully designed townhouses around the world.

One of the most interesting elements in these houses is the windows. These often feature highly elaborate frames, surrounded by decorative brick- or stonework, and are a real delight to draw on their own, regardless of the rest of the house. These windows often contain many panes of glass, which sometimes reflect light, and at other times almost appear to absorb it. The trick to drawing the glass in windows is contrast. A very strong, black tone can be used to indicate the depth of the room

behind the window, while a flash of white paper left unshaded will act as a reflection, indicating that there is something between the outside of the house and the rooms. Sometimes you will be able to see curtains. These are ideal, as they allow you to introduce middle tones as an element of balance in the study. The tonal range of the ideal window would consist of an intense 6B shaded section in between 2B softly shaded curtains, with a flash of white paper streaked diagonally across the windowpanes.

As these windows will nearly always be set back into the wall, you will need to look closely at the point where the frame and the surround meet. This is where you will find the shading that will add solidity to your study and allow your townhouse to come alive on paper.

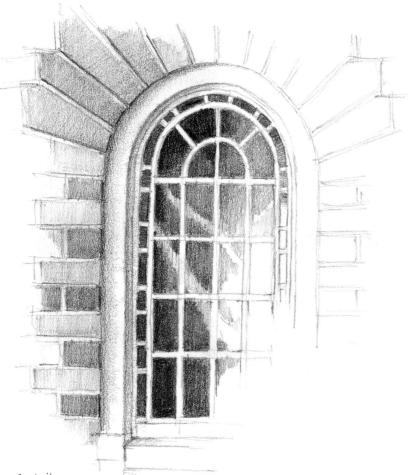

Details
Window frames and brickwork need to work together visually. Always look for the way in which directional lighting creates shadows on the different sections of the whole window.

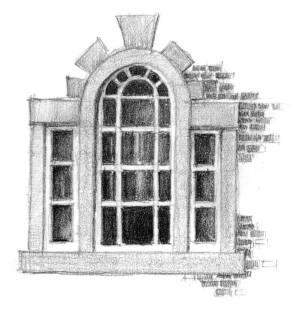

Technique
Glass can often be recorded by drawing the light – either reflected by the glass or absorbed by the room behind. Don't be afraid to shade the glass with a 6B or 8B pencil.

Georgian townhouse

The variety of tones in this building meant that a variety of techniques and several pencils had to be employed. Line shading, cross-hatching and much pressure on 2B, 4B and 8B pencils were all used.

Positive and negative brick shapes often look particularly effective when used side by side. Try varying the pattern.

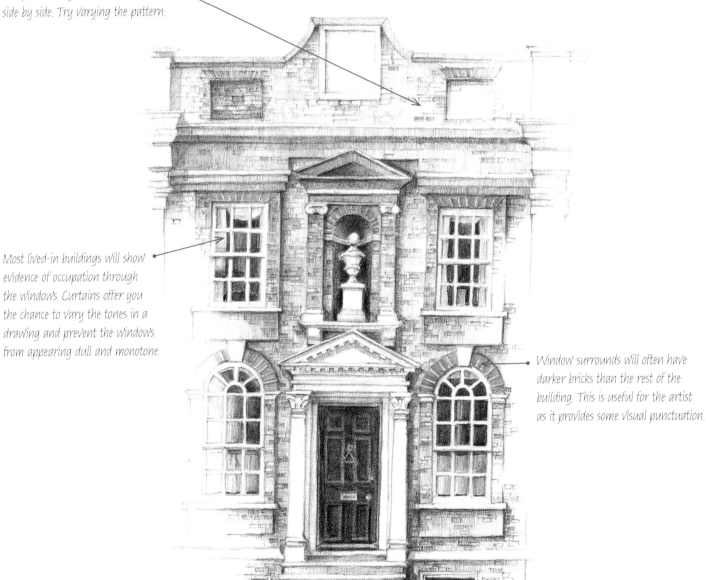

Most lived-in buildings will show evidence of occupation through the windows. Curtains offer you the chance to vary the tones in a drawing and prevent the windows from appearing dull and monotone.

Window surrounds will often have darker bricks than the rest of the building. This is useful for the artist as it provides some visual punctuation.

Terraced buildings

Long rows of terraced buildings are a common feature
in many towns and cities. They were usually built to fit as
many small dwellings as possible into a limited space. The
most appealing terraces nowadays are those whose occupiers
have added their own external modifications, creating lots
of very different houses all joined together in a row.

As both length and height are key features in terraced
buildings, you will often find that stairways and basements
abound. These are wonderful subjects for studies as they
contain a wealth of angles, interesting perspective lines and
unusually shaped shadows. Water-soluble graphite pencils
are a good medium for recording the contrast between the
solidity of the brick, stone and iron of the stairs, and the
softness of the cast shadows.

Water-soluble graphite pencils are good for drawing
terraced buildings for another reason: they allow you to
create the effect of depth and distance through washes. They
are also particularly valuable for drawing windows. You can
draw the darkest tones, leaving a slight flash of white paper
untouched and then, with a fine, damp paintbrush, pull the
tone from the dark shading around the white stripe. This
creates a new range of softer middle tones without you
having to change pencil or do any additional drawing.

The dark shading, washed out to middle tones, is a
technique that is also highly conducive to drawing the bay
windows that are a common feature of terraced buildings.
It allows you to create the shaded section with the darkest
tones and then pull the tone around to the front of the
window, where the highlights will usually be found.

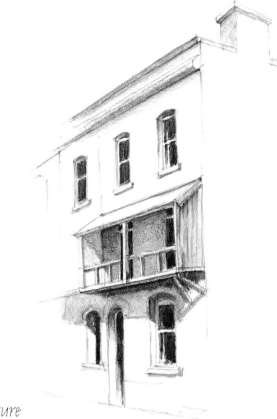

Structure
As space in terraced houses is often limited, balconies are
common. Look for the angle of shadows cast, especially the way
they fall across inset windows and doorways. This can make a
flat wall come alive with light and shade.

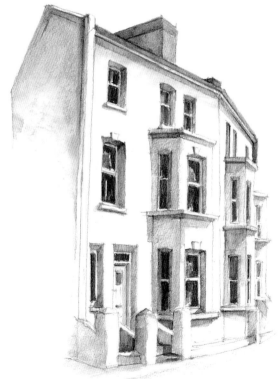

Tones
The variety of tones in this drawing were created using just one
pencil. They were achieved by varying the pressure while drawing
and by the prudent use of water when washing across the water-
soluble pencil marks.

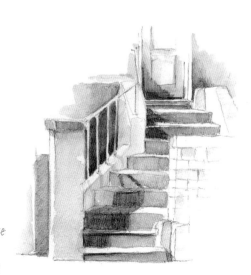

Details
Stairs and steps are
always worthy of a
study; look for the
intricate patterns
created by shadows
from railings. Draw
these on top of a base
tone to increase the
depth of the shadow.

Brick terrace (detail)

Water-soluble pencils are well suited to producing detailed drawings as, when washed over, they diffuse the pencil lines without completely destroying them.

It is a good idea to allow a few specific lines or pencil marks to show through despite the water washes.

Not all features need to be washed over. These railings were drawn on after the wash had been applied, so they still retain their linear appearance.

The darkest tones may require several applications of water-soluble graphite pencil to achieve a real depth.

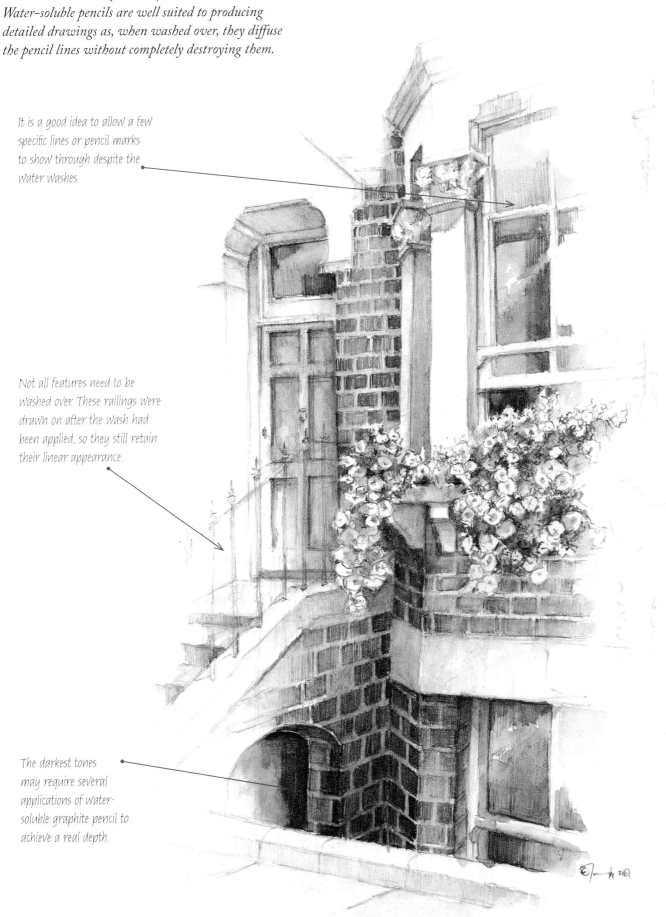

Modern buildings

Many towns and cities have seen the rapid rise of contemporary buildings, which have often been built as showpieces for the commercial centres of key districts. These buildings are frequently constructed from glass and steel, with the structure being open for the world to see – and draw! Both glass and steel reflect their surroundings rather than absorbing them as more traditional brick or stone structures might. So, instead of looking for the patterns created by masons and weather, we must look for the rhythmic reflections of the adjacent buildings. However, the techniques for drawing these two building materials do vary a little.

Glass allows you to see in as well as reflecting some light. You will want to create the dark tones to suggest the depth of the room beyond while tracing the patterns that can be seen in the reflected light – these will often be of a lighter tone. Steel, however, only reflects, giving a much brighter surface to record. To create the sharp, cold reflections from steel, you will need to use a sharp pencil – 2B should do. Observe exactly where the dark sections are on the reflective surface and draw these using a series of vertical, sharp lines. These should be drawn rapidly, with almost a flick of the pencil. This will ensure that the lines remain straight and don't begin to wobble as they might if drawn slowly.

You will find that these buildings are often very tall, and are usually sandwiched between other buildings. So you might like to reconsider the general rule that the composition should fit within a rectangle – in fact, some long, thin compositions may well develop from this stimulating environment.

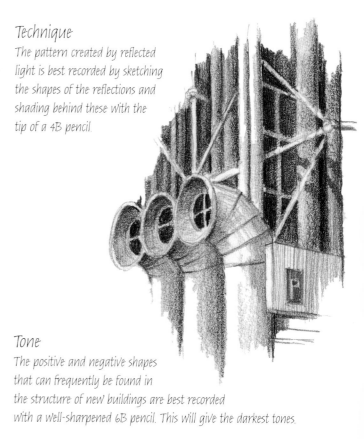

Technique

The pattern created by reflected light is best recorded by sketching the shapes of the reflections and shading behind these with the tip of a 4B pencil.

Tone

The positive and negative shapes that can frequently be found in the structure of new buildings are best recorded with a well-sharpened 6B pencil. This will give the darkest tones.

Steel structure

Unlike glass, steel will provide a sharp and clearly defined reflective area, but it will rarely produce a mirror image of any surrounding buildings.

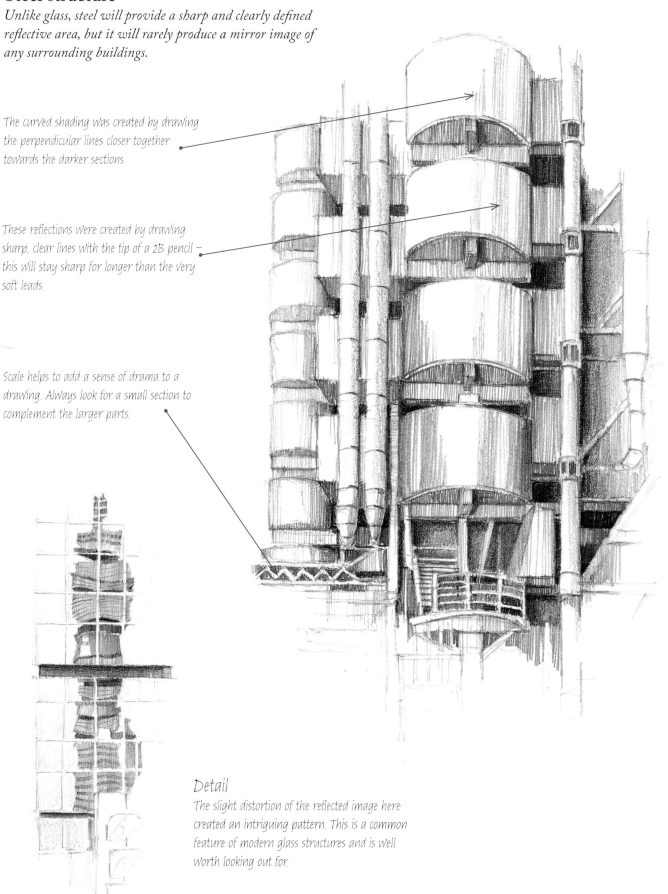

The curved shading was created by drawing the perpendicular lines closer together towards the darker sections.

These reflections were created by drawing sharp, clear lines with the tip of a 2B pencil – this will stay sharp for longer than the very soft leads.

Scale helps to add a sense of drama to a drawing. Always look for a small section to complement the larger parts.

Detail
The slight distortion of the reflected image here created an intriguing pattern. This is a common feature of modern glass structures and is well worth looking out for.

PROJECT: Italian scene

Most towns and cities have a cultural heritage. This is often at its most attractive in the old quarters, with buildings and cobbled alleyways where time seems to have stood still. As with the Italian urban corner shown in this project, you can't completely escape the trappings of the 21st century; road signs, satellite dishes and other urban peripherals will nearly always be in evidence.

In an area of such diverse building styles, I needed to make a selection of studies in order to understand exactly how the stone sat around the windows and in the arches. Questions such as whether the stone was darker or lighter than the bonding in between them, and whether the stones were used in a random way, or whether they were cut in a fairly even manner, had to be answered in my sketchbook. Always take the time to ask yourself how the elements in your sketch relate to each other as this will produce a much more informed drawing.

I used both 4B and 6B pencils to explore the stone, using the edge of the 4B pencil to create the soft tones, and the tip of the 6B to create the gaps in between and the occasional shadow cast from a protruding stone.

I soon discovered that with buildings of this age, the windows were not always set into the stone; this meant that the traditional wooden shutters sat flush with the wall. The key to success was clearly going to be the interplay of light and shade created by the relief nature of the walls. Once I understood this, I could move on to apply this knowledge to the whole composition.

Detail
This study explored the way in which the shuttered window sat within the stone wall; the flush fitting of the window meant that no shadows were cast from the wood surround.

Structure
The study of this stone arch explored the positive and negative shapes. The gaps between the stones appeared much darker than the stones themselves, and were drawn with the tip of a 6B pencil.

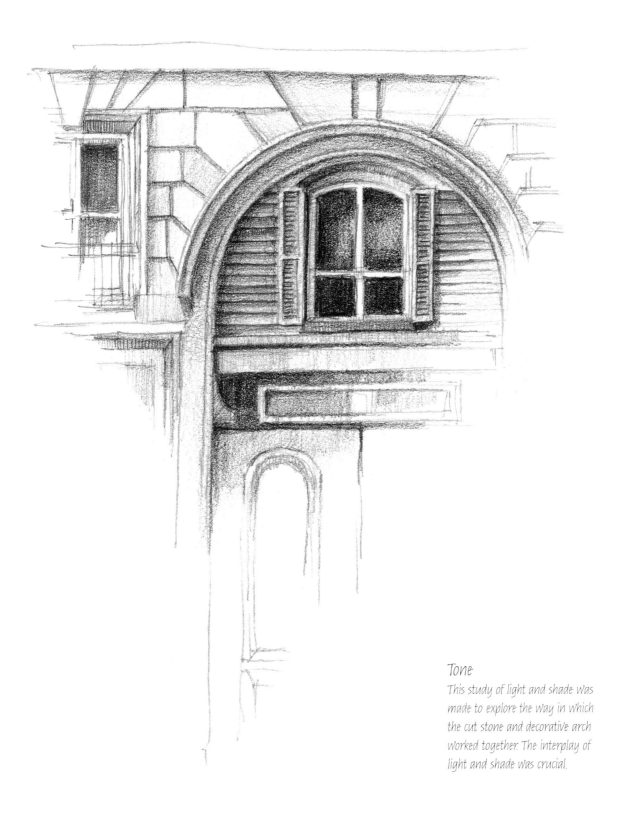

Tone

This study of light and shade was made to explore the way in which the cut stone and decorative arch worked together. The interplay of light and shade was crucial.

PROJECT: *continued*

As I had chosen a vantage point at the bottom of the steps, looking upwards, the main consideration for the composition was going to be perspective.

As many elements were involved, such as unusual doorways, arches, and varying heights, I decided to make a couple of sketches as dry runs before embarking on the main picture. These were not elaborate sketches, but simply experimental visual notes to test my vision and explore the techniques.

The standard artist's rule for creating distance is to lead the viewer's eye from dark foreground to light background. I felt that this approach would not produce such a successful composition. I chose to draw the viewer's eye from a light, negative foreground, right into the back of the composition where the darkest tones were to be seen in the covered alleyway. The result is, I believe, dramatic and much more effective. I found that in trying to achieve the matching sense of depth in the steps that ran alongside, I had to use a more specific drawing technique. In order to create a sense of rhythm in the steps, I alternated the angle of the shading lines, ensuring that the top of the steps was always shaded with short, sharp, vertical lines. These force the viewer's eye to jump from line to space all the way up the steps, just as your feet would if you were climbing them.

Finally, I introduced the figure to create a sense of scale and of time. On their own, the buildings seemed a little overpowering, and the figure of the man helped to suggest a slower pace of life.

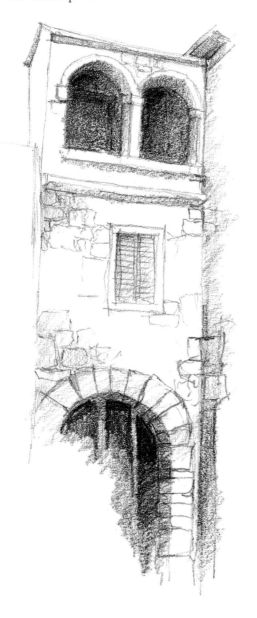

Tone
This quick sketch of the old tower was made with a 6B pencil, not only to establish its height but also to explore the strength of the shading inside arches.

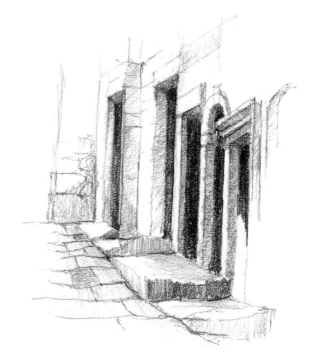

Perspective
The unusual perspective on these irregular doorways required an individual study before a large drawing was begun. I allowed my pencil to follow the base line rather than the tops of the arches.

The finished drawing

The picturesque nature of this quiet urban corner seemed to be complemented by the human clutter of road signs, washing and satellite dishes.

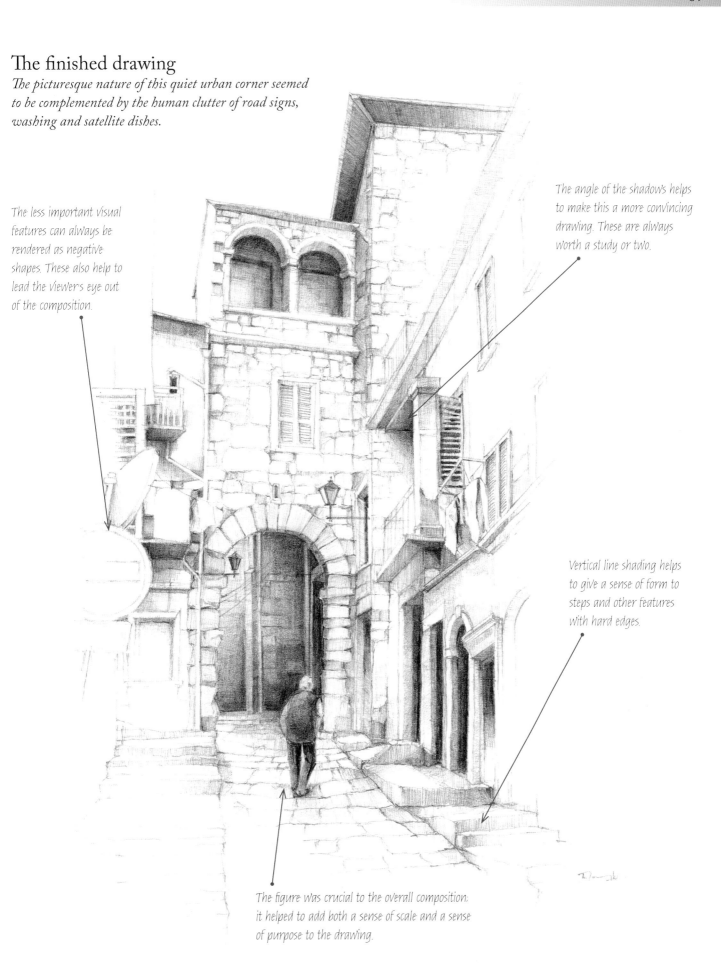

The less important visual features can always be rendered as negative shapes. These also help to lead the viewer's eye out of the composition.

The angle of the shadows helps to make this a more convincing drawing. These are always worth a study or two.

Vertical line shading helps to give a sense of form to steps and other features with hard edges.

The figure was crucial to the overall composition: it helped to add both a sense of scale and a sense of purpose to the drawing.

CLASSICAL ARCHITECTURE

By classical architecture, I am referring chiefly to the style of building that has its roots in the design that emerged from the Italian Renaissance, based on ancient designs, and later spread throughout the world. Many classical emblems have their origins in natural designs – leaves feature frequently, for example.

This style is not only found in buildings of the 15th and 16th centuries: it is a style that has been embraced as a method of decoration ever since its conception. However, the more authentic, and usually more interesting, examples are often to be found on older buildings such as churches, museums and universities.

As this section of the book concentrates more on drawing smaller details of buildings, rather than whole buildings, there are a few different approaches that need considering. Firstly, you will need to devote a little time to training your eye to follow some involved patterns as you pick out the veins of leaves, folds of drapery and rams' horns as they appear around columns and above decorative door arches. The delicate interplay of light and shade on these carvings is another area of consideration, as is the subtlety of perspective on such a small scale. While the principle of observing highlights and creating the appropriate shadows to visually push the light areas forward still applies, the technique of applying this needs to be a little more intense and this, in turn, will influence your choice of materials.

The other important area for exploration is texture: these features will usually be made of stone, and the following pages are in part devoted to examining some of the ways in which you can record the texture of crumbling stone, and the ravages of age and weather.

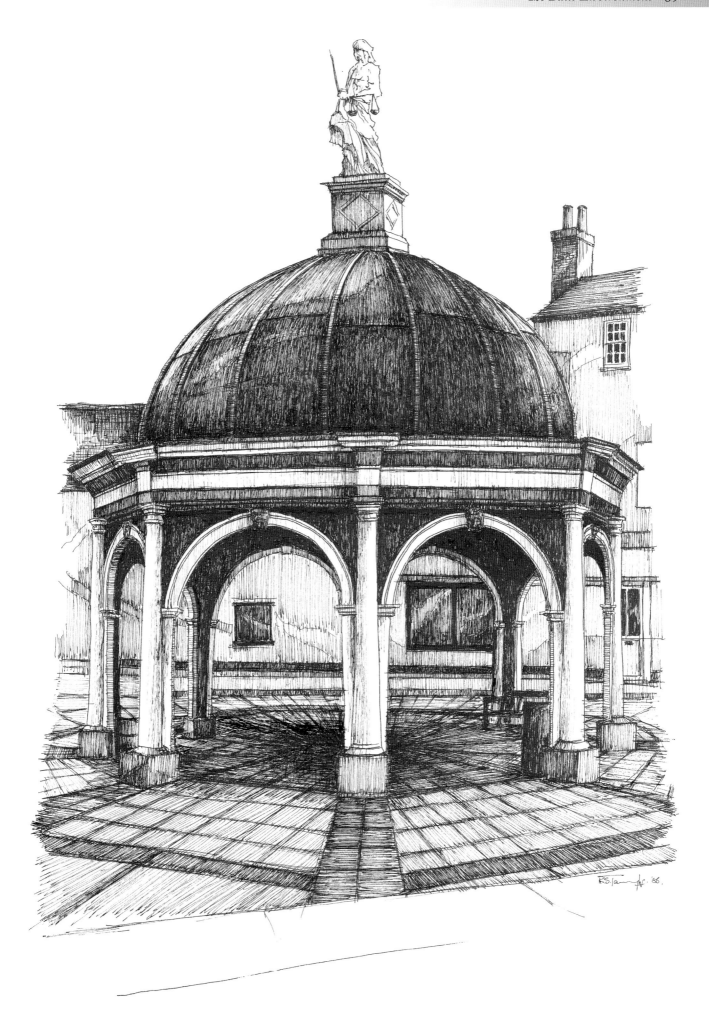

Churches

Churches are always an excellent source of classical motifs with which to fill sketchbooks; they are rarely shy about displaying their cultural richness on their exteriors.

While some churches are small and compact enough to draw on their own, many of the larger churches will provide enough material to keep you sketching for hours. The sketching process is important, as it helps to improve your hand–eye coordination.

Given the complexity of many traditional decorative carvings, you may find the best method of sketching to be a combination of line and wash. One technique that is worth experimenting with is drawing within a small area of paper without taking your pen tip from the paper. This will force you to concentrate on joining up the tiny leaves and scrolls found at the tops of columns, and makes you sketch at a quicker pace. Once you are happy with the line drawing, you can proceed to create the three-dimensional appearance by adding an ink wash using a small, soft paint brush. Then pick out the shaded areas between the raised sections of the relief carving, and leave the highlights untouched.

There are many ink colours that you can choose from; experimenting with different coloured ink washes is time well spent. Brown and sepia inks are conducive to drawing churches as they give a slightly older, antique feel to your drawings – even more so if applied to slightly tinted papers.

Detail
Studies are good for training your eye to record the complex structure of architectural details. When you first start out, work with line only, as this simplifies the process.

Tone
Using a small brush, you can experiment by adding tone (Indian ink and water), picking out the shadows and leaving the highlights.

Colour
Experiment with different coloured inks. A warm, sandstone red can glow with the southern sun, while an antique brown can impart a more mellow mood.

Italian church front

While the grand scale of this impressive church was initially a little intimidating, the pure symmetry made it easy to construct. After that, you can choose how much information you include.

The use of brown or sepia ink can lend an old or antique feeling to a drawing, especially if the building itself is from a much older period.

Sharp shadows are best produced by not overloading your brush with ink; decisive, one-off applications are more effective.

The sharp light of the day meant that hard, clearly defined angular shades were needed. These can be sharpened with pen lines if required.

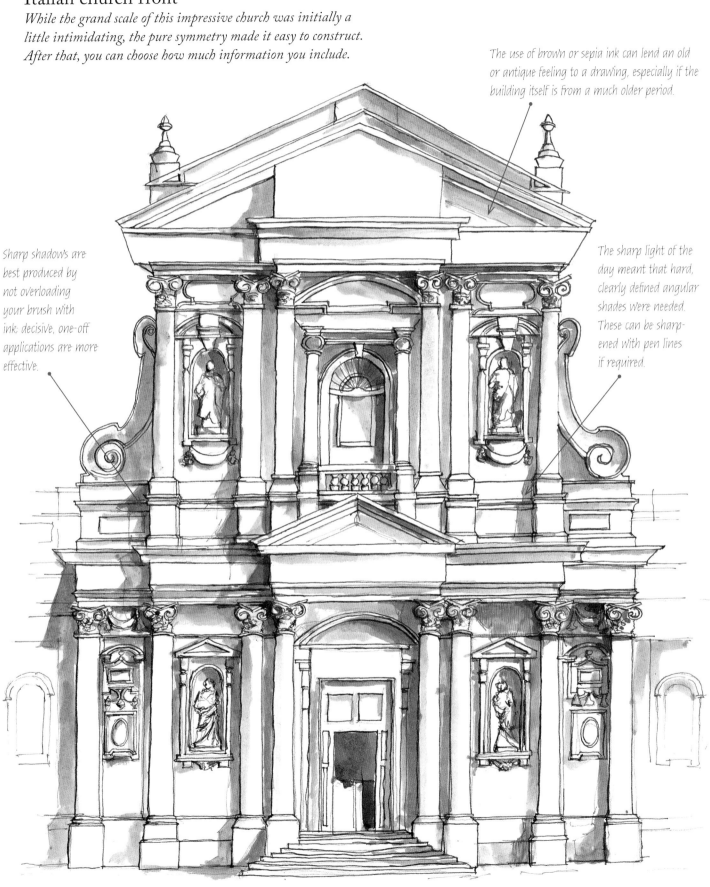

Statues

Having mastered picking out light and shade on the exteriors of churches, the next step is to move on to drawing statues. These will sometimes appear in relief and sometimes as freestanding three-dimensional monoliths.

One of the first decisions that you will have to make is exactly how much of your subject to include in your drawing. Sometimes you may want to focus on one section of a statue, or on a group of figures. Alternatively, you may wish to draw a complete freestanding statue – in which case, you will need to decide whether you include the surroundings.

Most of these decisions can be resolved through the choice of an appropriate drawing technique. If you are looking to isolate a small section of a large statue, think about fading out the edges by the use of graduated shading. Instead of taking your drawing out to a hard-edged finish, use the edge of the pencil lead and shade away from the centre of the drawing, easing the pressure on the pencil until it barely touches the paper.

If you are drawing a statue in its natural surroundings, you might like to use the technique of creating positive and negative shapes. Negative shapes of surrounding objects can suggest that your subject is not in isolation, but that it is the positive shapes of the statue that the viewer is to concentrate on, rather than the unshaded peripheral buildings.

Tone

Stone is solid and will always look so. You will need to use some hard shading to make statues look as if they have been carved. Statues are ideal for drawing in graphite pencils, as these allow you to create boundless tones. You may have to take this medium to its limits: work with an 8B pencil to achieve the darkest of tones in the depths of large statues that little natural light can penetrate.

Technique

Try drawing statues with a 2B and an 8B pencil. This will allow you to create the contrast of shade and highlight that is so characteristic of carvings.

Detail

Let your pencil follow the lines of carved drapery, then shade in between the raised highlights to create negative shapes.

Italian fountain

With freestanding statues and fountains, it is best to ignore the background periphery, as this can be visually distracting. A stand-alone drawing is usually best.

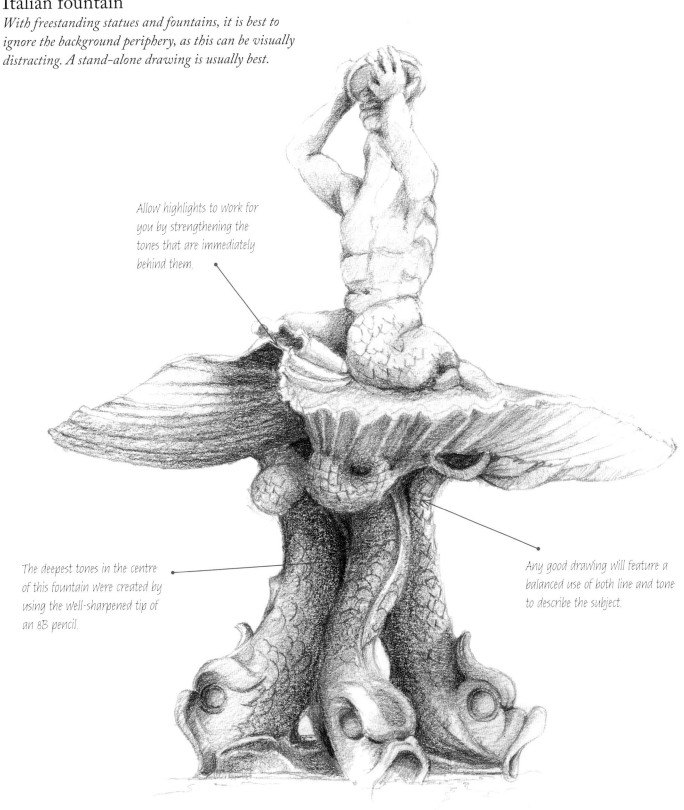

Allow highlights to work for you by strengthening the tones that are immediately behind them.

The deepest tones in the centre of this fountain were created by using the well-sharpened tip of an 8B pencil.

Any good drawing will feature a balanced use of both line and tone to describe the subject.

Relief carving

University towns almost always feature a wealth of subjects to draw, as their streets often contain centuries of history. The classical relief carvings and features on university buildings celebrate their wealth of knowledge and learning, and complement the buildings perfectly.

Drawing these old, weatherworn buildings can be made a little easier by the addition of watercolour, but it will also mean breaking a few conventions! Many watercolour painters are appalled by the existence of watermarks, or cauliflowers, as they are sometimes known. These occur when watercolour paint is allowed to dry without having been properly blended. The final result is more of a stain with a clearly discernible outside edge. These marks are, however, absolutely ideal when drawing buildings. They are even to be actively encouraged, as they help to suggest the textures of ageing plaster and damp stains on centuries-old stone, and will only serve to enhance your finished work.

Using your materials to create textures is a vital part of the drawing process and is always worth experimenting with. Having created colour and texture within your drawing, you may find that the depth of tone in some of the sections needs to be strengthened. You can increase the amount of paint by dabbing a darker colour in the appropriate place. Alternatively, you might like to use a fibre-tip pen to draw on to the section that is casting the shadow, and then pull the ink out with a damp brush to create the depth of tone required. This may also dry with a hard edge, thereby enhancing the texture of your building.

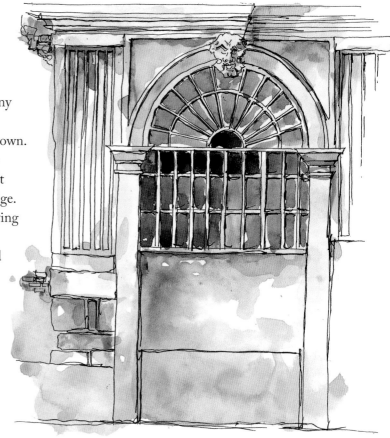

Detail
The addition of burnt sienna can give both a brick and a rust tone to a picture. In this study, it served both purposes.

Detail
Never cover the entire paper with a watercolour wash. Always allow a little white to show through here and there as highlights.

Technique
Use a stone colour (usually raw sienna), wash freely to create an old stone effect, and allow it to dry. Watermarks can help to add texture to a study.

Oxbridge gateway

*Centuries of weather exposure had eroded much of the detail
on the relief carvings surrounding this wonderful old gateway.
This necessitated a subtle approach to the shadows and shading.*

The shadow tones were created by
drawing over the initial drawing with
a water-soluble fibre-tip pen and then
washing over this with clean water.

Once the colour wash dries, you can
strengthen the shaded sides of carvings
by loosely drawing over the original lines.

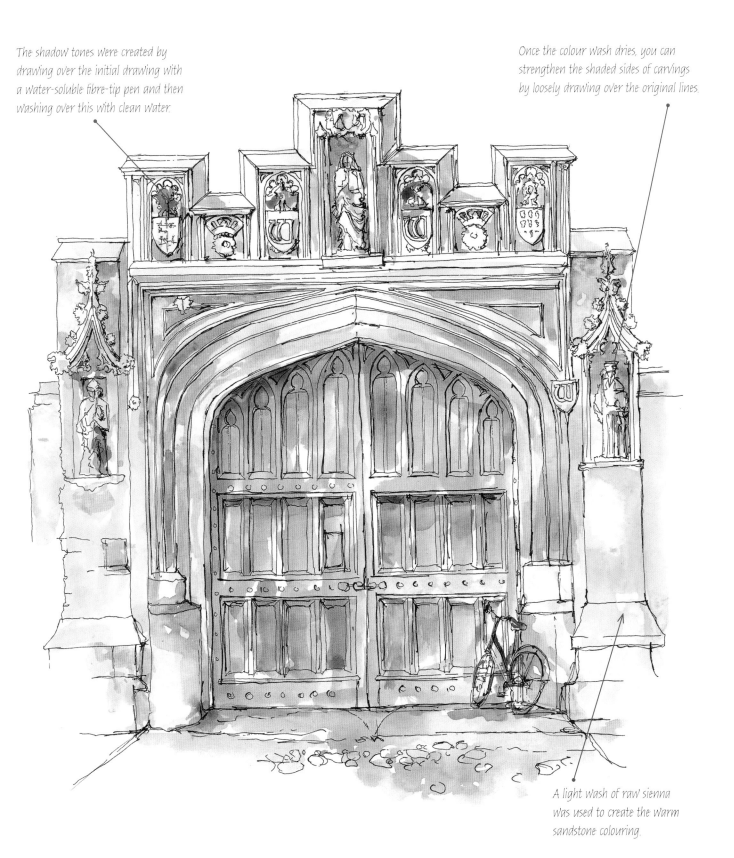

A light wash of raw sienna
was used to create the warm
sandstone colouring.

PROJECT: Stone moulding

I love capturing the quality of old stone with the medium of graphite powder. They share so many physical characteristics.

The old carved stone fountain that I chose to draw for this project was, naturally, part of an older built environment. All around the area I found similarly textured and toned subjects, all of which served as ideal warm-up exercises for me prior to starting work on the main picture.

I find that it helps to be able to use more than one finger when applying graphite powder as, like pencils and brushes, your fingers are usually of different sizes. Having made a simple outline drawing, my first application of graphite powder will usually involve a whole-hand approach; I use at least three fingers to cover the area of paper to be toned. I will then use my index finger to control the movement of the powder

a little more, making additional applications where darker tones are required. To reach the smallest of sections, I will use my little finger to dab some powder into a drawn crevice or large crack. At this stage, when I begin to add details, I will usually spray the drawing with fixative. This will prevent the powder on the paper from moving, allowing me to build up the surface of graphite on the next application without disturbing or altering the tones that are already established.

You will find that you can achieve much greater control over your powder if you complement its use with a pencil. I like to use at least a 6B pencil to finish off the edges of a drawing, or to work into the shadows to deepen the shading with a few sharp lines. You can also use the tip of your pencil to manipulate graphite powder, creating a wonderful combination of solid pencil graphite and the softer powder on your drawing.

Detail
The decorative carvings found under the eaves of buildings can be drawn with a 4B pencil and a light rubbing of graphite powder applied with a little finger.

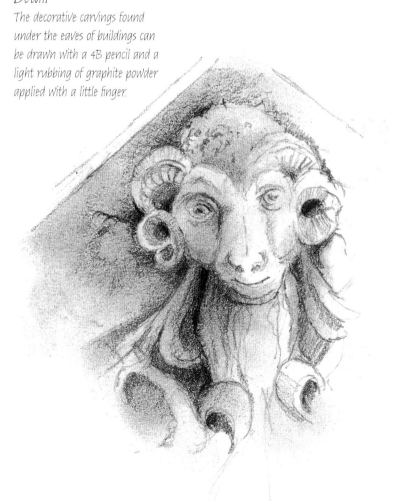

Technique
Textures can be created by sprinkling some graphite powder on to paper then fixing it with fixative spray. Before this dries fully, sprinkle more powder and fix again: this builds up the appearance of ageing stone.

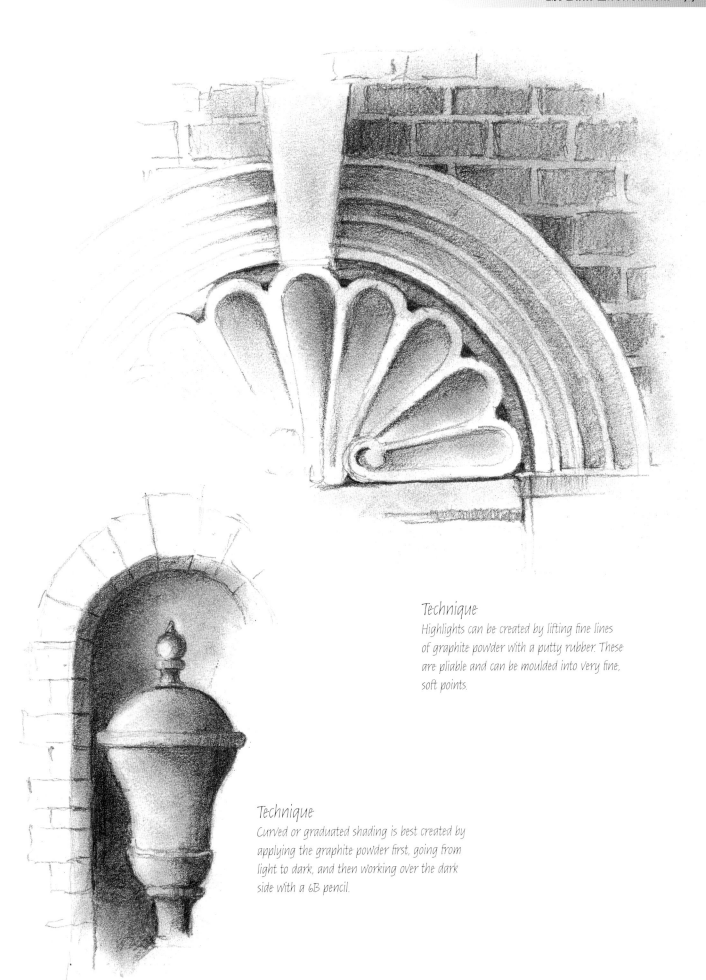

Technique
Highlights can be created by lifting fine lines of graphite powder with a putty rubber. These are pliable and can be moulded into very fine, soft points.

Technique
Curved or graduated shading is best created by applying the graphite powder first, going from light to dark, and then working over the dark side with a 6B pencil.

PROJECT: *continued*

The real appeal to me of this old statue was the way in which the cracked plaster had fractured and revealed another texture lying underneath – brickwork.

Before committing myself to the main picture, I experimented with a small section. I found that the raised plaster was best drawn by running a line of graphite powder on one finger along the line of the fracture. I then cut into the plaster with the sharpened point of a 6B pencil, and extended this line along the edge of the graphite powder. The next stage was to make the plaster look as if you could insert your finger underneath it and lift it from the paper. This was achieved by using a 6B or 8B pencil to shade as hard as I dared on the brick section, directly underneath the plaster. This dark shading contrasts with the light plaster, visually pushing it forward. The final stage was to sprinkle some powder on to the plaster and spray it with fixative to secure the light coating on the page.

I also felt that I wanted to experiment with the facial features to establish the techniques that I would use in the main picture. The accuracy necessary to copy the eyes, nose and mouth required a combination of graphite powder for the soft tones and graphite pencil for line and control. I also introduced a putty rubber into my toolkit for this section, lifting the graphite powder from the central line running along the nose and the eyebrows. This is a useful technique, but it needs to be done before you spray with fixative as it will be too late afterwards!

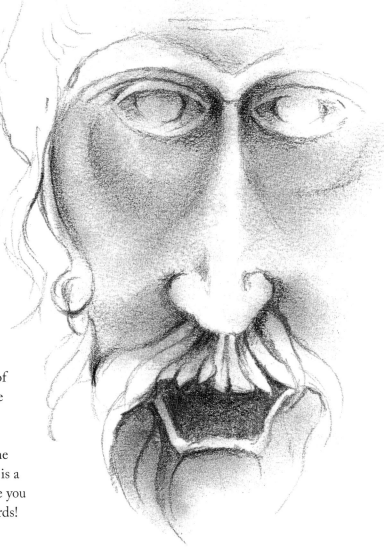

Tone
A wide variety of tones can be created with graphite powder by making several applications, one on top of the other. This can be finished off with an 8B pencil to achieve the deepest black.

The finished drawing

*The combination of accurate carving and random weathering
made this a highly appealing subject for graphite powder work.*

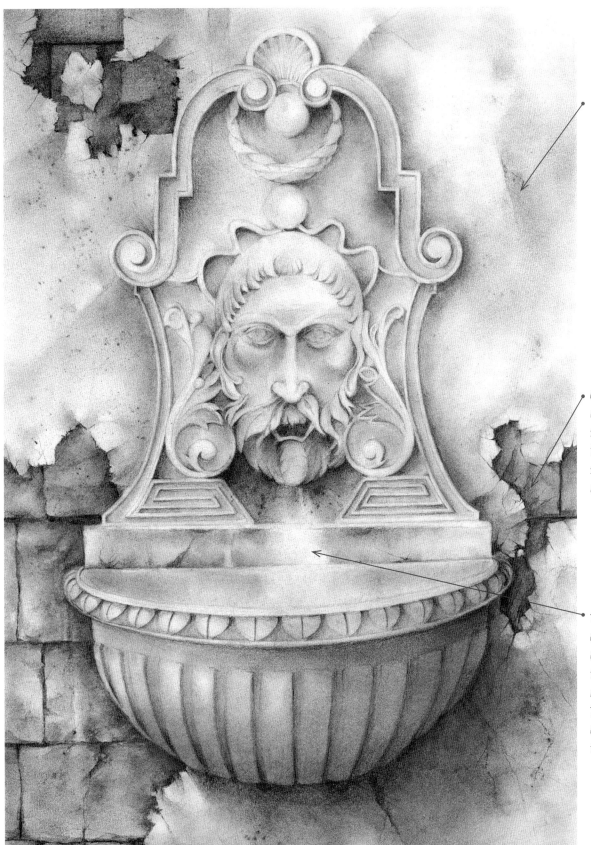

The raised or blown plaster effect was created by gently lifting some of the graphite powder with a putty rubber. Use a soft, dabbing technique for the best effect.

Cracked plaster was drawn with a highly sharpened pencil tip, creating a hard, sharp line to suggest ageing cracks.

The appearance of worn stone was created by working the graphite powder around a white space. This has the effect of visually 'cleaning' the stonework.

PUBLIC BUILDINGS

Civic offices and buildings, designed to serve the needs of communities, may seem unlikely to make inspiring choices for drawing. However, artists react to what they see, rather than to preconceived notions. These buildings often have a purely functional purpose, but were usually built when either local or national pride was important to their community; this feeling of patriotism is often reflected in their architecture.

I have always found this combination of functional design and local flamboyance particularly fascinating, as it can produce some very unexpected designs and structures. The 19th century in particular produced some buildings of remarkable visual authority. At the time of construction, these buildings would probably have lacked the qualities we might seek in a suitable drawing subject. However, modernization has injected a new element of life into many of these structures, turning them into excellent subject matter.

In terms of technique, these buildings will often be well suited to the box structure method of drawing, allowing you an easy opportunity to turn a simple, geometric shape into the exterior structure of a plain, functional, but well proportioned, public building.

Another consideration when recording public buildings is that you will often find members of the public on the scene. Railway stations are an excellent example of this. Built to serve a public need, stations will nearly always be awash with people. The following pages offer some suggestions as to how best to deal with crowds of figures, and exactly how much detail you might include in your drawings.

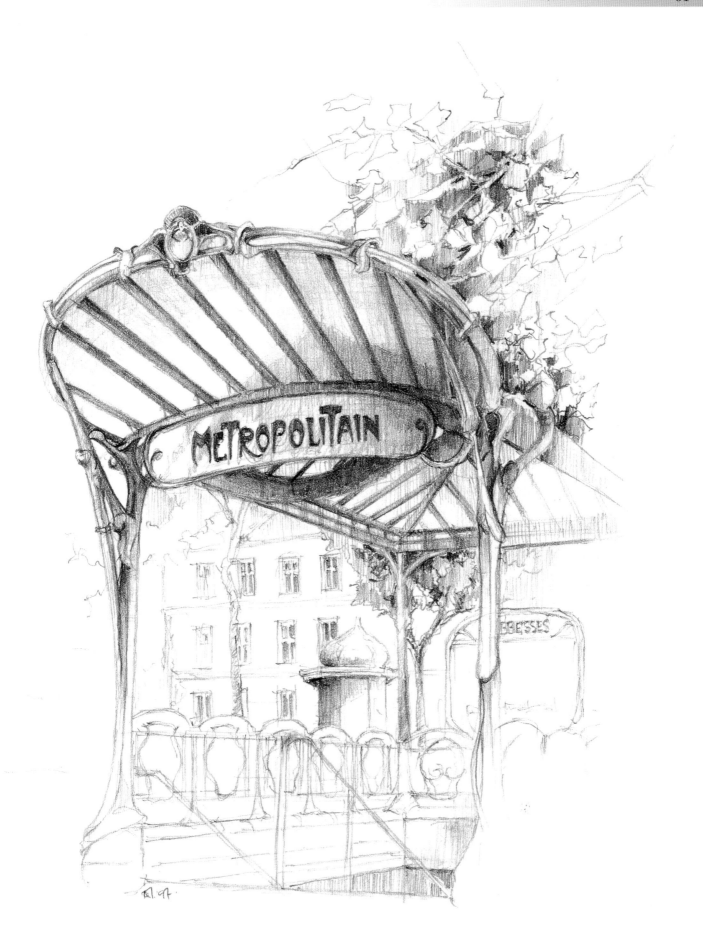

Railway stations

Railway stations are transitory places. They are designed to accommodate masses of people for a limited time only. They also reflect the power and wealth of the age in which they were built.

Railway stations usually have two distinct sections: the bare, skeletal structure of the interior supports, and the ornate, inspiring exterior. Once inside a railway station, a vast array of subjects are to be found. Because of the size and scale of some places, you are bound to find that perspective will dominate your drawings, as long sweeping lines of metal and steel will invariably be visible.

You will rarely find a station devoid of human life – and people usually appear in crowds. The best way to deal with this is to view people as you might bricks in a wall: you will have to employ the technique of suggestion. You might treat some figures as negative shapes set against the detail and tone of the building, with only one or two selected for a more detailed treatment.

Figures will also help to lend a sense of scale to the building. They can help to establish a sense of perspective in your composition, especially if you emphasize one or two figures in the front of your line of vision.

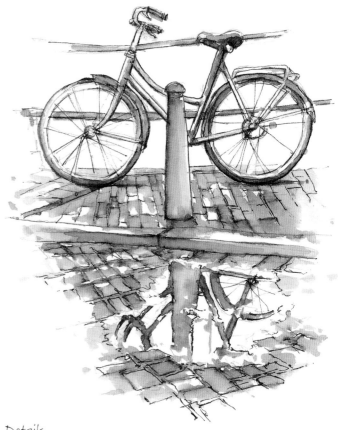

Details
Functional signs and elements such as station clocks and ticket offices offer good sources of subject matter. Remember that drawing buildings is not always about the buildings themselves.

The combination of the sharp roof perspective lines and the solid vertical pillar were the features that attracted me to this part of the station. Always look out for contrasting lines in order to create exciting sketches.

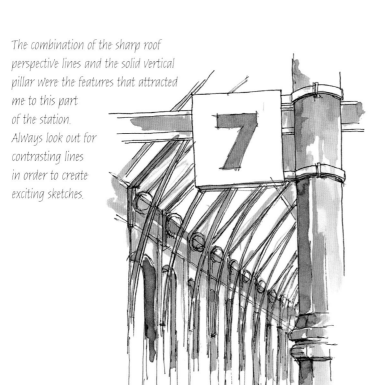

The station clock is an important part of railway architecture. Try to create the glass front by leaving a white streak or flash between washes to act as a reflection.

Luggage will always be a feature at railway stations and can be used to fill a few idle minutes in sketching.

Amsterdam Central Station

The huge size of this building was, at first, a little intimidating – but simplification of the detail was the solution to producing an uncluttered drawing.

It is not always possible to include every facet of large buildings, so suggestion is usually the best way to fill spaces.

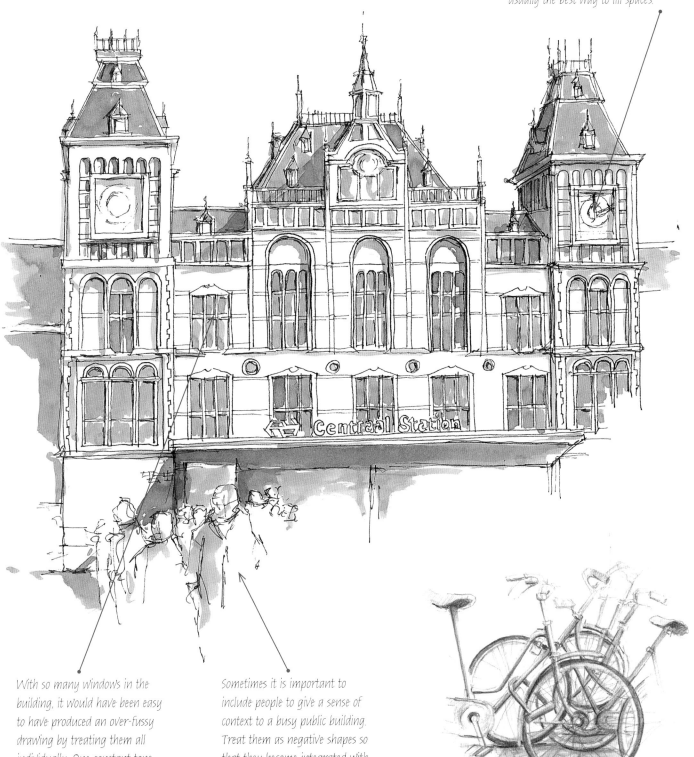

With so many windows in the building, it would have been easy to have produced an over-fussy drawing by treating them all individually. One constant tone unified them all.

Sometimes it is important to include people to give a sense of context to a busy public building. Treat them as negative shapes so that they become integrated with the scene.

19th-century public buildings

Many buildings remain from the 19th century, especially the public buildings, rigidly disciplined in style, which still stand strong.

Symmetry and predictability are the key features of this type of building. Although many additions have been made and their appearance changed over the years, the doors, windows and gables still remain as stoically balanced as they ever were. For artists, these buildings are a real blessing.

The symmetry of these buildings will allow you to construct a section – full view or angled view – of these buildings very easily. Start by drawing the box structure following the perspective guidelines. Then add one vertical line in the middle of the box, as the horizontal line already exists (that is, the imaginary horizon). Then line up the features while still following the perspective guidelines.

As these buildings were made largely of bricks, water-soluble graphite pencil is often a good medium to use. This will allow you to fill large areas of wall quickly without having to worry about creating some form of tonal unevenness, purely for effect. No brick wall ever appears as just one tone, so you can just suggest a few bricks with the dampened tip of your pencil.

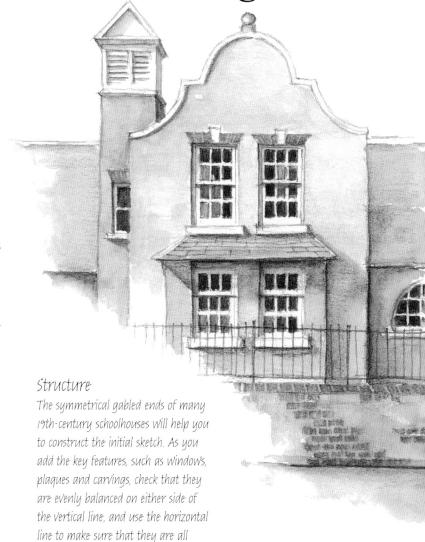

Structure
The symmetrical gabled ends of many 19th-century schoolhouses will help you to construct the initial sketch. As you add the key features, such as windows, plaques and carvings, check that they are evenly balanced on either side of the vertical line, and use the horizontal line to make sure that they are all lined up correctly.

Detail
The carvings and decorative features found around doorways are often worth studying in water-soluble graphite pencil. The washing process can create quick and easy shadows.

Carnegie Library

The shape of this building enforced some serious consideration of the viewpoint. I knew that the tree was an important feature, so I had to choose the best angle from which to draw it.

The tone of the tree needed to be varied as it was a very dominant section of the composition – both dark and light tones were carefully balanced.

The shadows and `shading that help to define this building's character needed to be sharp and definite to bring out its best qualities.

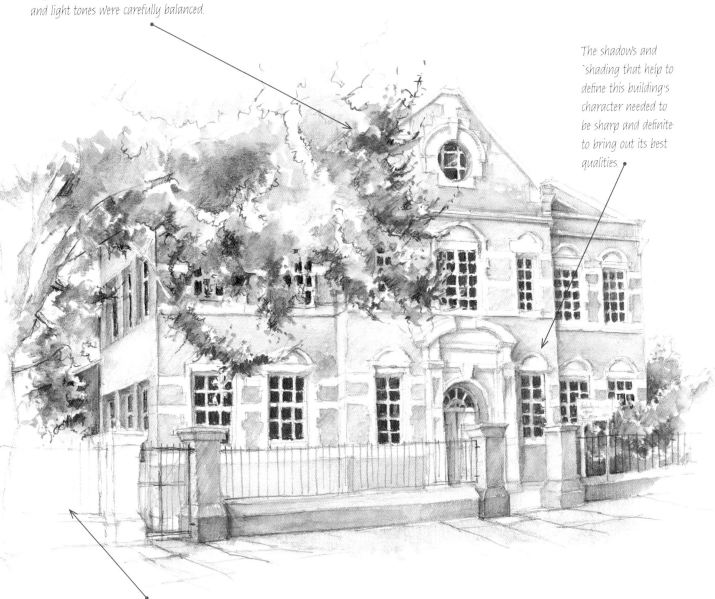

Fading out is a useful compositional device to employ in large scenes when you are not certain exactly where to end the drawing.

PROJECT: Town hall

Sometimes there is more to a building than just the brick and stone that it is constructed from. Occasionally, a building can take on a special association just by hanging some flags or bunting from the door. This is often the case with town halls: they are built specifically to act as the centre of the community, and celebrating their identity is an important function.

In making a few preliminary studies for the composition of this particular town hall, it seemed appropriate to me to explore the flags as well as the building, even though they occupied only a small amount of visual space:

their significance, however, was considerably greater as they helped to give the building its specific identity. I was fascinated by the twists and turns of the flags as they fluttered in the breeze, and soon decided to use watercolour to capture this effect.

As the stonework had been developed using a variety of techniques, a few studies were required to enhance my knowledge of this particular building. I soon learned that the stone always appeared to be lighter than the recesses. I then proceeded to apply a wash of raw sienna for the overall stone colour.

Technique

Stonework on public buildings is usually interesting to draw. A light raw sienna wash was used to add some colour to this sketch. Once this had dried, I used the tip of a small brush to draw the lines of the recesses with an even mixture of ultramarine and burnt umber, adding a little more ultramarine to create the shadows underneath the stone-arched window surrounds.

Colours used

Raw sienna.

Burnt umber.

Ultramarine.

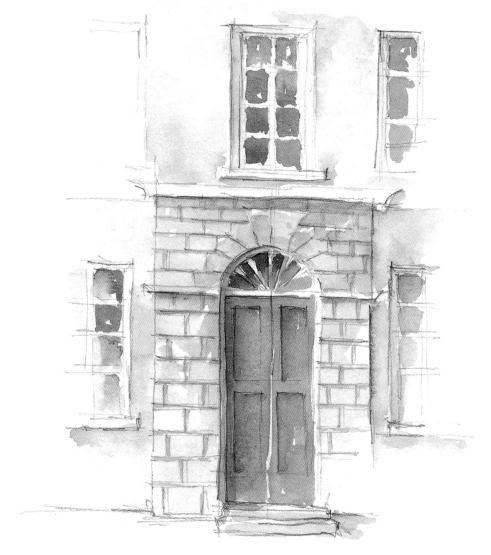

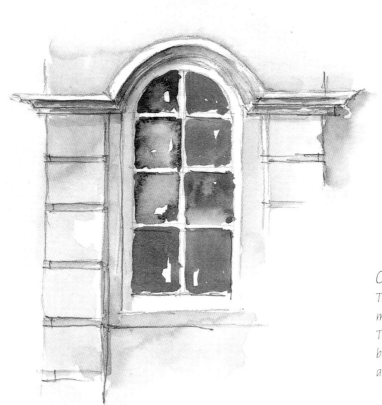

Colour

The window colour was created here by mixing burnt umber with ultramarine. This was applied with the tip of a very wet brush to allow a free flow of paint, thereby avoiding brushstrokes.

Colour

The flash of colour offered by flags and bunting can often break up the flatness of old stone buildings. Look for the folds and twists and copy the lines of colour for the best effect. I made a very quick pencil sketch of the simplest of triangular and rectangular shapes, observing the twist as they were caught on the breeze. I then used a mixture of ultramarine with just a touch of burnt umber to wash behind the twist, creating the idea of a slight shadow.

PROJECT: *continued*

I used my knowledge of perspective box construction to draw the overall shape of this town hall, I soon realized that the key to creating a successful picture would be to ensure that the window frames and doorways were correctly painted. This would prevent the walls from looking flat. A fine balance was required at this point; I did not want to lose the strength of the line drawing by overworking the paint, but was aware that some differing tones were required. After some thought, my eventual aim became to apply a functional tint, maintaining a light touch with the paintbrush and working with dark tones only when really necessary.

So, having sketched in the window and door shapes, I applied a liberal wash of a thin raw sienna mix using a medium-sized soft watercolour brush. I allowed this to dry thoroughly before the next stage. While the paper was drying, I changed to a smaller brush and created a mixture of ultramarine and burnt umber. I ran this around the inside of the window frames to suggest shading. While this was drying, I changed the balance of the paint mix to three-quarters ultramarine and one-quarter burnt umber. With this colour, I was able to paint the windows as the blue was more conducive to reflecting the sky – even though the colour actually appeared to be grey.

The final stage was to add the colour to the flag, reinforcing the national identity and importance of the building. Sometimes it is the smallest of details that can make the biggest difference to a drawing of a building.

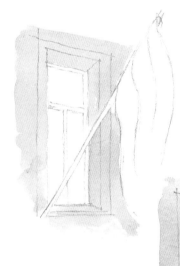

One colour
The first stage of creating washes so as to add form to the drawing was to wash raw sienna across all the stone area using a large, wet brush.

Colours used

Raw sienna.

Burnt umber.

Ultramarine.

Two-colour mix
To create a sense of recession, I mixed some burnt umber with the raw sienna and applied this in one stroke using the tip of a thin brush.

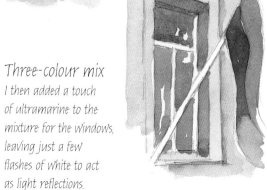

Three-colour mix
I then added a touch of ultramarine to the mixture for the windows, leaving just a few flashes of white to act as light reflections.

The finished picture

The box-like shape of this traditional town hall was complemented by the size and shape of its many windows. They helped to give the building a light and airy feel.

Leaving some decorative details as white flashes can help to visually break up a large expanse of wall, giving your drawing a lighter feel.

Don't submit to the temptation to over-work the painting element. A light wash is all that is needed to add colour to tint a drawing.

A very light watercolour wash was applied with a watery brush. This allowed for a free flow of paint and a non-uniform application, just like an old building really looks.

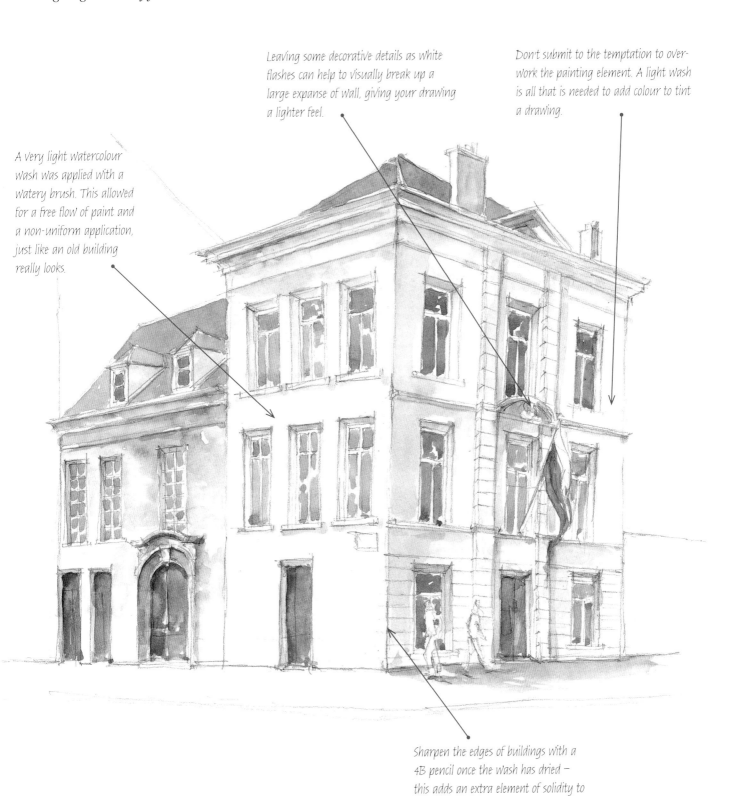

Sharpen the edges of buildings with a 4B pencil once the wash has dried – this adds an extra element of solidity to the drawing.

STREET ARCHITECTURE

This section of the book aims to explore the peripherals that make any built environment something more than just a collection of brick, cement and stone buildings.

Subjects such as signs, posters, café tables and market stalls are all part of everyday urban life and they serve to visually enliven any built environment. Often these details may be left out of a scene because we don't consider them to be a legitimate part of a single building or collection of buildings. But the street is only an extension of a building, and so anything of interest that appears on the street is worthy of inclusion in our drawings.

This is the section where we look in a little more depth at the way that figures interact with buildings, and exactly how we might approach sketching them and using them to help make sense of certain built structures – without the people, the building may not have a purpose.

Most of the next section explores the visual impact that objects positioned in front of buildings have on a particular scene. Boards set outside seaside fish stalls, people shopping at a street market, drinkers at a café – all are viewed against a built backdrop, but which is the most important? The background and foreground in a drawing must not compete for the viewer's attention. This is an important consideration, and will be addressed in the following pages.

The purpose of most street signs is to direct, advise or warn us. To compete with the visual cacophony of commercial signs enticing us to shop, these signs must be bright and simple. The way in which colours can be used to record these valuable contributors to the built environment is considered, alongside the techniques required to make them look even better by adding a few rust stains.

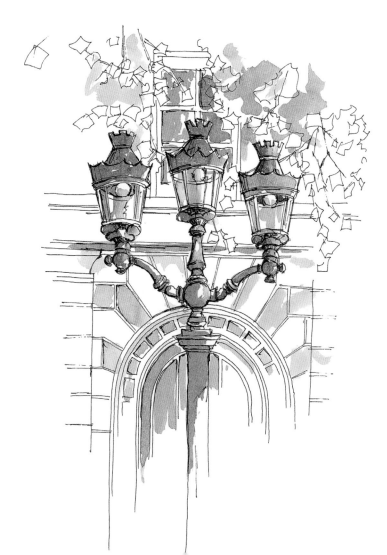

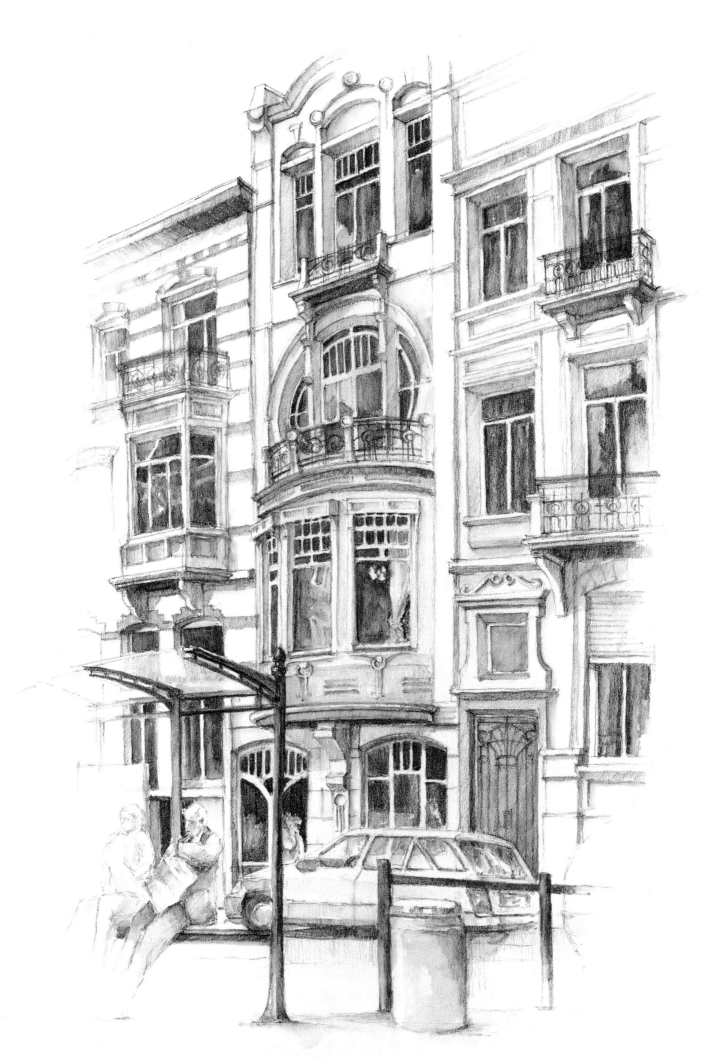

Cafés and shop windows

Cafés, bars and restaurants should be welcoming places; they are often fronted by large windows and doors, allowing you to see inside and be tempted by the delights within. Unlike residential windows, however, these windows will often be covered with signs, stickers and information, creating a host of visual clutter for you to draw.

As you will usually be able to see further inside these buildings than you would the average domestic building, working with pen and ink will help you to achieve the blackest of tones by using pure, undiluted ink (in moderation, that is). Treat this technique as you would a watercolour wash applied to a pen drawing, except you work with tones of grey rather than variables of colour. You can draw the main linear structure of the building, including any of the objects visible inside the café or bar window, with an ink pen at first. Then, in a saucer or plastic pot, mix a watery solution of Indian ink with water. Using a soft brush, wash the light tones across the building and windows. Then quickly add more ink to the saucer to create the medium tones, and wash these across some of the lighter tones. You will now have three tones on your building. Finally, dip the tip of your brush into your Indian ink pot and use thin, deep, black ink to touch in the darkest tones.

Use this technique sparingly – you will lose the visual impact of the contrast if you over-use the black. Then you may wish to add a few more pen lines to reinforce, or partially enclose, some of the tonal shapes that have been created through the wash to suggest part of the fabric of the building, adding a new dimension to your technique.

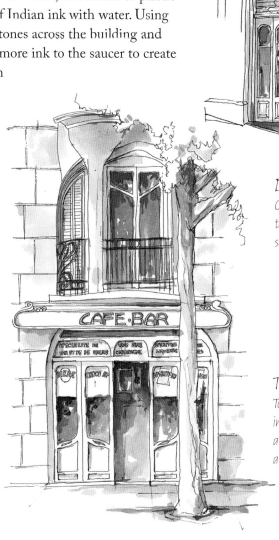

Detail
Curved windows will often require curved shading. Try to include a flash of white that follows a curved line to suggest the window's shape.

Technique
To achieve the required depth of tone inside a shop, bar or café, try applying a watery wash of Indian ink, followed by a few undiluted dabs of pure ink.

Shakespeare & Co., Paris

The complexity of the visual information found in this scene meant that not just a technique but a medium for suggestion was critical – pen and wash.

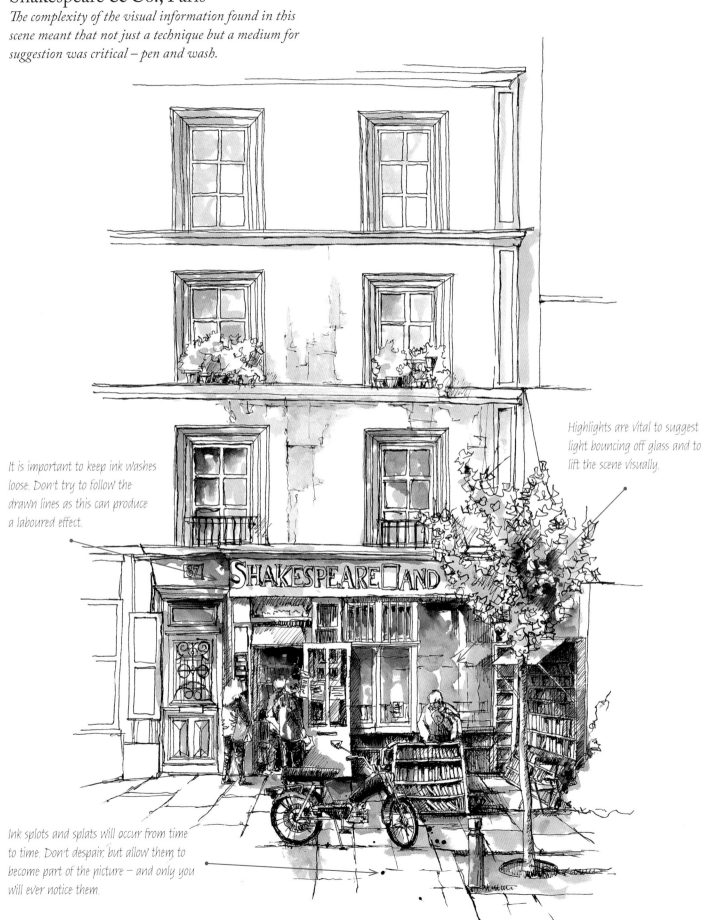

Highlights are vital to suggest light bouncing off glass and to lift the scene visually.

It is important to keep ink washes loose. Don't try to follow the drawn lines as this can produce a laboured effect.

Ink splots and splats will occur from time to time. Don't despair, but allow them to become part of the picture – and only you will ever notice them.

Street cafés

You cannot really sketch altogether successfully in the built environment without including some people in your work. This applies particularly to street cafés where people gather, sit, drink, talk and generally watch the world go by. That is the very reason for the buildings' existence – they offer somewhere for people to go.

On a more practical note, you might wish to make it absolutely clear what you are doing – furtive sketching and looking at individuals who are minding their own business can (but only on rare occasions) provoke an undesirable reaction.

In terms of technique, you may find that a selection of pencils will be most suitable for this type of drawing. To capture a figure in context you will need to be quick and fairly accurate. You are not drawing a portrait, but you will want the facial features to be in the right places. Water-soluble graphite pencils are ideal for creating the bulk of a figure, such as the coat and the hair. Standard graphite pencils will give you the necessary sharpness for sketching facial features.

The most important consideration, however, is that your figures interact with their surroundings. Ensure you place equal emphasis on tabletops, chair legs, window and door frames. It is important that your studies are seen to be the integral part of the environment that they actually are.

Don't be afraid to leave key parts of your composition as negative shapes; you are unlikely to have the time to record everything that you see before your subject moves.

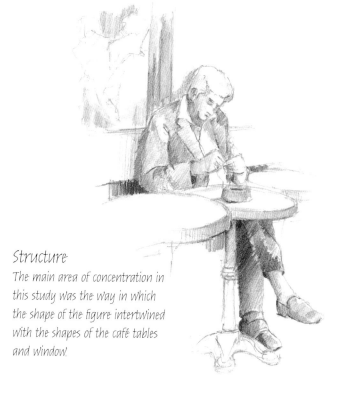

Structure
The main area of concentration in this study was the way in which the shape of the figure intertwined with the shapes of the café tables and window.

Tone
Water-soluble graphite pencils are ideal for making quick sketches. You can block in the dark and light tones before your subjects move and then use water to create the subtle tones later on.

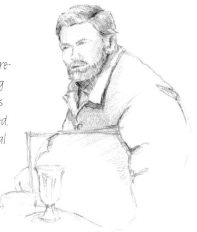

Detail
Although not strictly building-related, you will find that making studies like this café artist helps to improve your sketching speed. They also provide good material for home-based compositions.

Parisian street scene

A café or bar without people would be an unusual, and probably quite uninteresting, scene to draw, so always try to include some human interest in these scenes: it reinforces the purpose of the building.

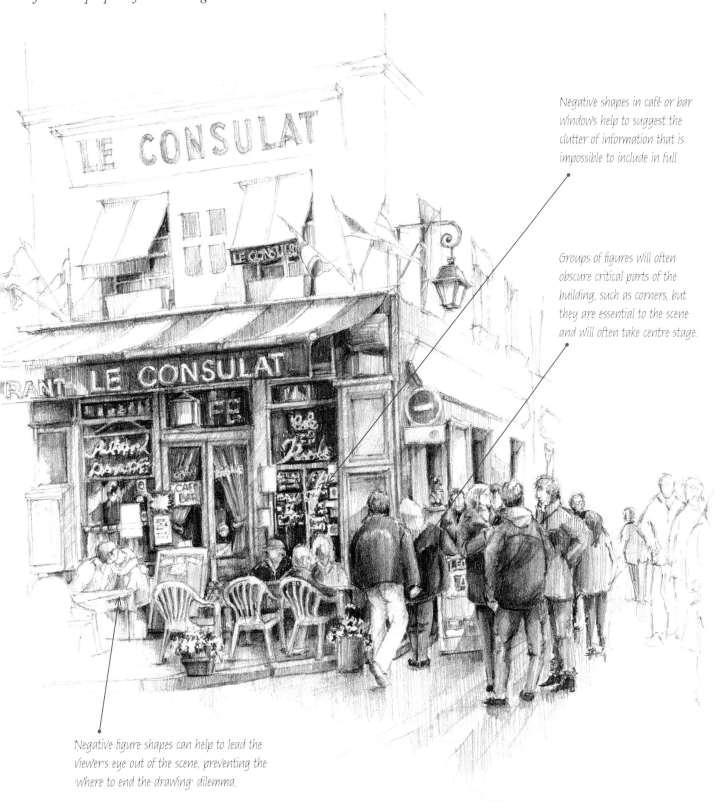

Negative shapes in café or bar windows help to suggest the clutter of information that is impossible to include in full.

Groups of figures will often obscure critical parts of the building, such as corners, but they are essential to the scene and will often take centre stage.

Negative figure shapes can help to lead the viewer's eye out of the scene, preventing the 'where to end the drawing' dilemma.

Road signs

Road signs can add a flash of colour to the dullest scene, capturing our attention and at the same time providing ideal sketchbook subjects. They also give us some valuable information!

As the majority of these signs will be made of metal, they are more liable to rust, and this can make them more visually appealing. In order to create authentic rust bleeds, you will need to make a couple of trial runs, as timing is critical.

Colour

As the purpose of road signs is to attract our attention and direct us quickly, they often use primary colours and a simple, uncluttered style of lettering.

Technique

Mix a watery version of the base colour (you will need a lot of water as this paint must not dry too quickly) and apply this liberally. Work up a strong mixture of burnt sienna watercolour paint and apply this with the tip of the brush to the exact spot from which you want your rust stain to bleed outwards. If the first application of paint is still wet, the burnt sienna will simply run and gently blend in with the paint. If you wait too long and the paint has dried, you will end up with a rust dab that will not look convincing. The key is to wait until the surface water has evaporated but the paper itself is damp. This is the time to apply the burnt sienna, as it will gently bleed into the damp fibres of the paper.

Parisian street corner

The clutter of visual information in this scene appealed to me chiefly because of the colours: the sharp, clear road signs stood out against the subtle, faded paintwork.

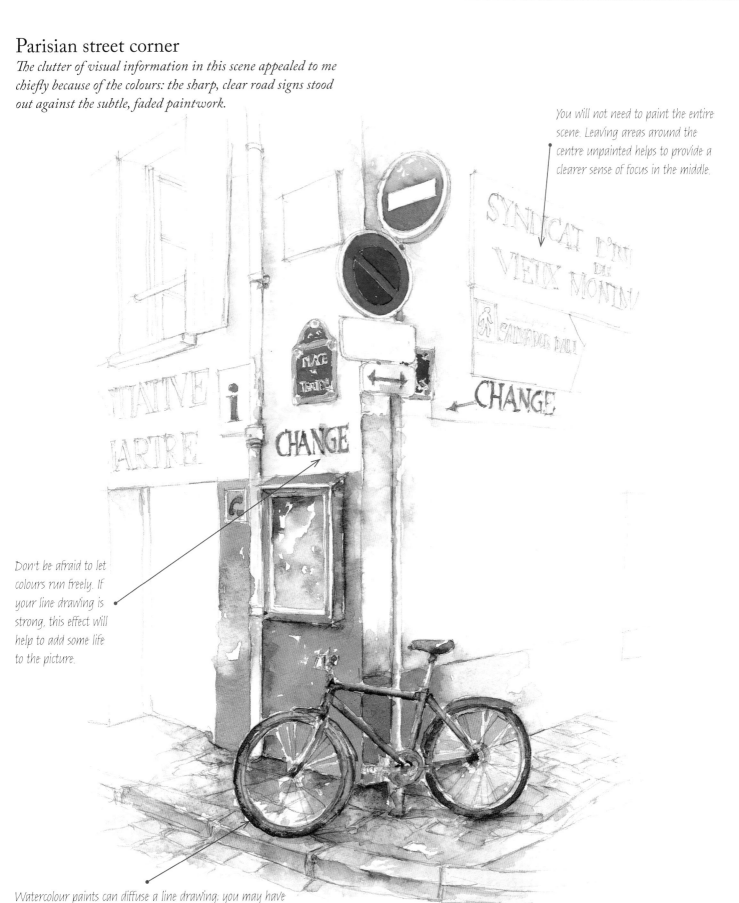

You will not need to paint the entire scene. Leaving areas around the centre unpainted helps to provide a clearer sense of focus in the middle.

Don't be afraid to let colours run freely. If your line drawing is strong, this effect will help to add some life to the picture.

Watercolour paints can diffuse a line drawing; you may have to redefine some shapes by drawing over them again with a sharp 2B pencil once the paper has dried.

Seaside buildings

Seaside buildings are unique. They always seem to exude a distinct character that is rarely attributable to any particular building style or genre. They are, generally, a fascinating amalgam of functional, streetwise buildings and open, shed-like stalls.

The one thing that you notice about these buildings is that they are rarely dwarfed by other buildings on the seafront, as they are often in the full glare of the sunlight. This, in turn, can produce some harsh, angled shadows.

Another fascinating visual aspect of these buildings is the number of signs that they display. Having practised on a few single road signs, the next stage really is to practise drawing the array of lettering and illustrations that you will find on seaside buildings. The commercial and temporary nature of these places means that they often employ collapsible or movable signs or display boards, often leaning up against an outer wall. It is worth studying these, as their angles can create strong shadows that have a dynamic effect on the foreground of your composition. When using pencils, you will need to create a very dark tone in the V shape that is created by the sign and the object against which it is leaning. This will push it forward visually. You will also need to ensure that you draw the shadow cast from the sign on to the ground. This anchors the sign to the surface, and prevents it from looking as though it is hovering just above the ground.

Tone
Roofs on seaside and pier buildings are often their most interesting feature and, unusually, are sometimes lighter than the fabric of the building.

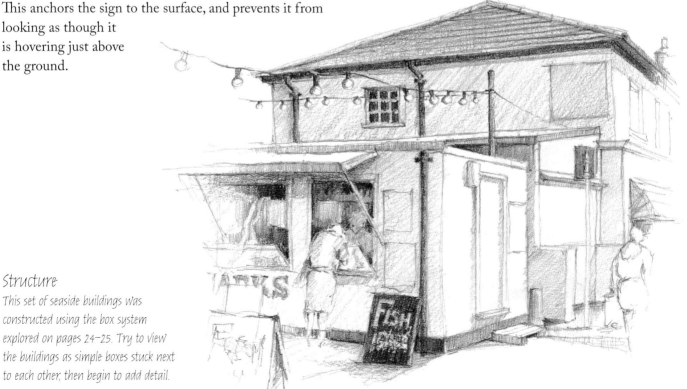

Structure
This set of seaside buildings was constructed using the box system explored on pages 24–25. Try to view the buildings as simple boxes stuck next to each other, then begin to add detail.

End-of-pier fish stall

Early morning is often the best time to draw scenes like this. Few people are around and the strong, long shadows help to add definition to the picture.

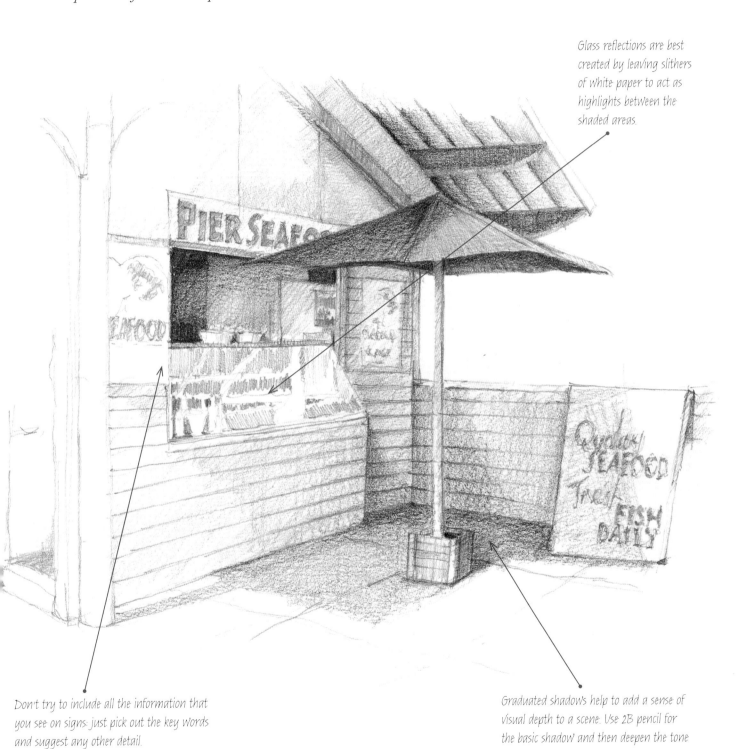

Glass reflections are best created by leaving slithers of white paper to act as highlights between the shaded areas.

Don't try to include all the information that you see on signs: just pick out the key words and suggest any other detail.

Graduated shadows help to add a sense of visual depth to a scene. Use 2B pencil for the basic shadow and then deepen the tone with a 6B pencil.

PROJECT: Street market

Street markets offer a wonderful source of subject matter for artists; it would be very easy to spend an entire day drawing and sketching at such a place.

At first I was tempted to use colour in my picture of this particularly vibrant street market. However, I found that as I sat and watched the scene unfolding before me, I was becoming increasingly interested in the way in which the market stalls and peripheral structures fitted in with the buildings that lined the street. In the end, it was the interplay of light and shade that captivated me more than the colours, so I decided to draw the scene simply using pen and wash which gives a nice, minimalist effect.

As the market traders began to set up their stalls, I became distracted by the emerging shapes and patterns. The baskets of produce, set into their checked gingham cloths, made an intriguing study. Equally, the public became more interesting as they positioned themselves among the forest of umbrellas, signs and stalls.

Although all of these studies were not essential to the drawing of the final picture, they helped me to develop a greater understanding of the many facets that go to make up a market scene. Even if they were not all included in the final drawing, they certainly informed the decisions I made when I was drawing it.

Detail

A street market has many features, one of the key ones being produce. A small study such as this helps to focus your attention on the intensity of the light and shade. Loose, yet intense, shading was the key to success here.

Tone

This study of one of the buildings on the street housing the market was made to explore the dappled shadows cast by the early morning sun. The study was drawn very quickly; a watery wash of Indian ink was rapidly pulled across the paper, using broken brushstrokes to record the dappled effect of the early morning light.

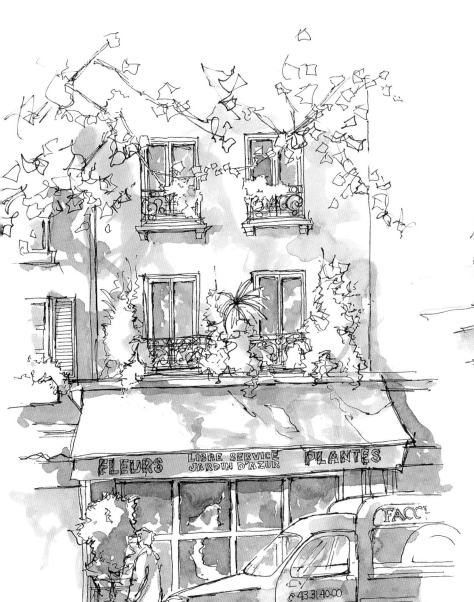

Structure

The way in which figures interact with their surroundings, such as umbrellas, stalls and goods, is a vital part of the street market environment. Pen and wash is ideal for speed sketching such scenes.

PROJECT: *continued*

The first stage of this drawing was to decide exactly what to include and what to leave out – these decisions were largely informed by the studies shown on the previous pages. While the height of the trees was critical, as they created much of the dappled shading in the foreground, I decided to cut their height to barely above the market stalls, simply because the stalls and the background buildings interested me considerably more than the tree tops.

Once the drawing was completed, however, I could sit back, close one eye and squint through the other to get a better idea of the key areas of light and shade. I proceeded to block these in with a watery wash of Indian ink, ensuring that the application was free and loose to prevent the picture from developing a stilted look.

Using a medium-sized brush, I started to work towards the foreground. I washed diluted ink across the cobbled stones towards the trees, and then darkened the sides of the trees themselves where they were caught in the shade.

Next, I prepared a less diluted mixture of ink. I set about washing this on to the deepest, darkest sections of the scene, under the umbrellas and directly underneath the aprons of the stalls.

The final stage was to go back to my ink pen and work more pen lines across the foreground, loosely picking out details, and occasionally overdrawing or reinforcing previously drawn lines that had become diffused by washes of ink.

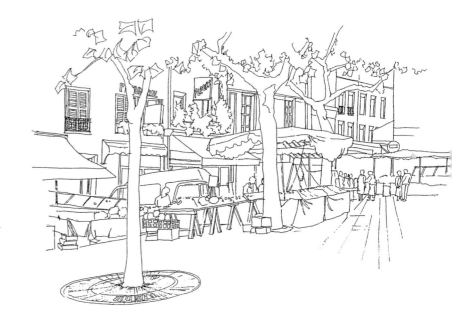

Structure
An initial line drawing was made to ensure that the key features were both in proportion and in the right place. This took some time as I had to explore the wide variety of shapes created by the legs of the stall, boxes and piles of discarded packaging on the ground.

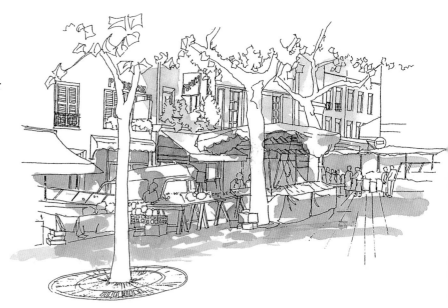

Technique
The next stage was to establish the blocks of shadow. These were washed across the line drawing very loosely with a large, soft brush dipped into diluted Indian ink.

The finished drawing

An early morning scene such as this, bathed in the intense light of the Mediterranean sun, was defined by the light and shade rather than the buildings and temporary market stalls and canopies.

It is important to establish the direction of the light, ensuring that shadows follow the corresponding line. Highlights help to clarify this.

While the foliage at the top of the composition helps to create the light and shade on the ground, the market stalls and the way in which they visually integrate with the permanent buildings is the most important element. Keep such foliage simple and unobtrusive.

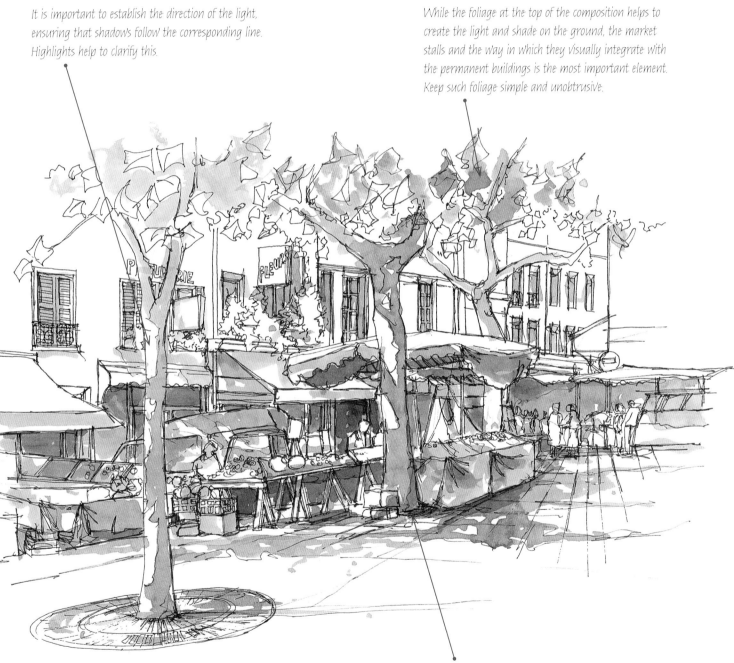

Once the ink wash has dried, the darkest areas can be strengthened by drawing on top of the wash with an ink pen. This also adds some life and a sense of movement to such a vibrant scene.

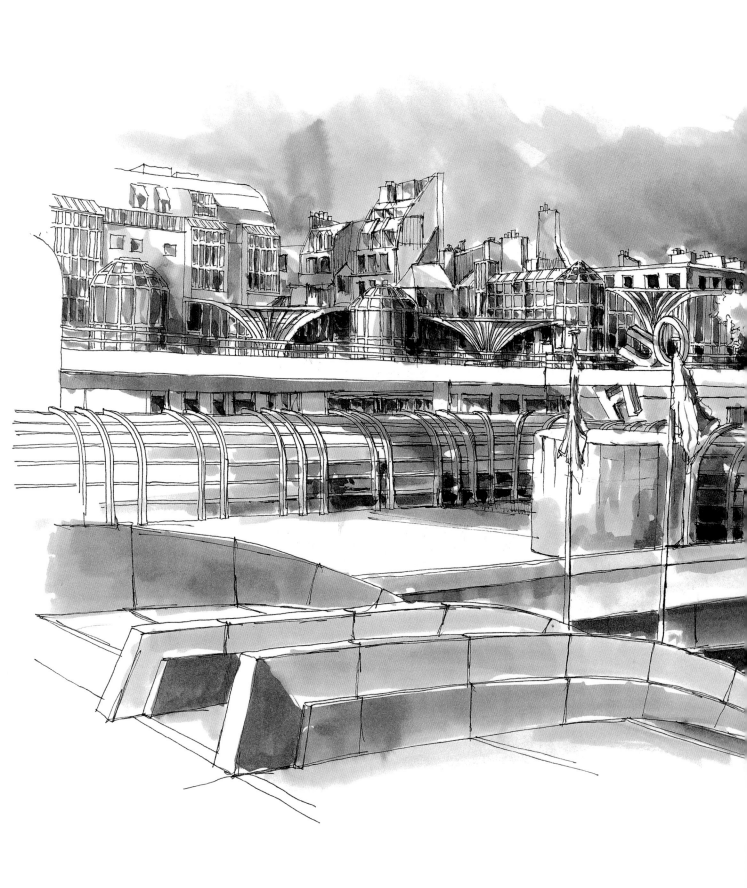

THE BIGGER PICTURE

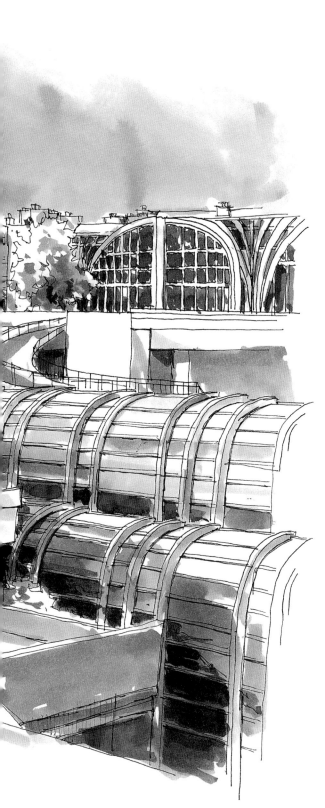

Up until now, this book has dealt with the idea of adopting conventional views of buildings and on-site sketching of what you can see immediately in front of you. This section, however, explores some slightly different ways of 'seeing' buildings.

Human eyesight is limited. We can only take in information presented directly in front of our eyes within a limited angle of vision. So what happens when we wish to extend that angle and look beyond the conventional viewpoint? The answer to this will usually be to put together a collection of images to create a 'wideangle' view that extends far beyond our natural angle of vision. The methods for achieving this, and some of the considerations regarding perspective conventions, are examined in the following pages.

This method of creating a drawing is itself restricted. What happens if we choose to extend our angle of vision not just along a single line, but above it and below it as well?

The following pages also explore the techniques involved in the creation of a panoramic view of rooftops across an open vista using photographs as a starting point.

These two projects have been left until the end of the book as they require some knowledge of many of the techniques explored so far. More important, however, is that they require the confidence that I hope you are developing by now – the confidence to make some decisions about how you personally wish to create a drawing. They are your pictures, and you are in control of how they will look.

Joiners

Sometimes you will stumble across a building that
you want to record, but have neither the time nor
the opportunity to sit and draw it. This is
even more frustrating if your viewpoint
is limited to a specific place, preventing
you from moving backwards far enough
to be able to take a photograph of the
whole building. This is the time to
consider making a 'joiner'. This technique
involves standing in one spot and taking
a selection of photos of your subject: a
portrait or landscape photograph alone
might be inadequate to record all of the
facets of the building.

Once the photos have been developed,
you can then assemble them, overlapping
where appropriate, and piece together the
final joiner to create an all-encompassing
photograph of your subject.

As you begin to draw from this multifaceted
image, you will notice that the perspective
has been distorted considerably more on the
portrait version than on the landscape print. This
is a natural reaction of cameras, and you will
need to decide exactly how much you correct
the perspective to make your drawing more
convincing. You will also find that not every
window ledge or column will match up when you
create your joiner – so don't try to trace or copy
the image directly.

Technique
To gain the maximum amount of visual information about a building, you
might want to use both landscape and portrait images taken from a single
spot. You may need to move your camera a little to record chimneypots or
decorative carvings along the roof.

Structure
A traced line drawing of the photo joiner
shows just how much the vertical lines have
converged through the camera lens. You
will have to use your discretion as to which
line you choose to follow to create your final
drawing. After all, a photo can be a useful
point of reference, but it should only ever
serve as a visual reminder. Slavish copying of
two-dimensional images often produces flat,
lifeless drawings.

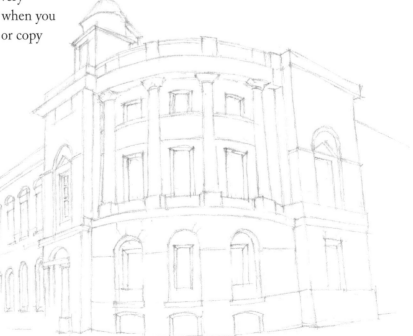

Classical building, Bath, England

Your eye must take over from the camera lens and correct the vertical lines before starting to work on the fabric of the building.

Curves are an important part of perspective. The curvature of a balustrade or balcony may need to be adjusted by eye.

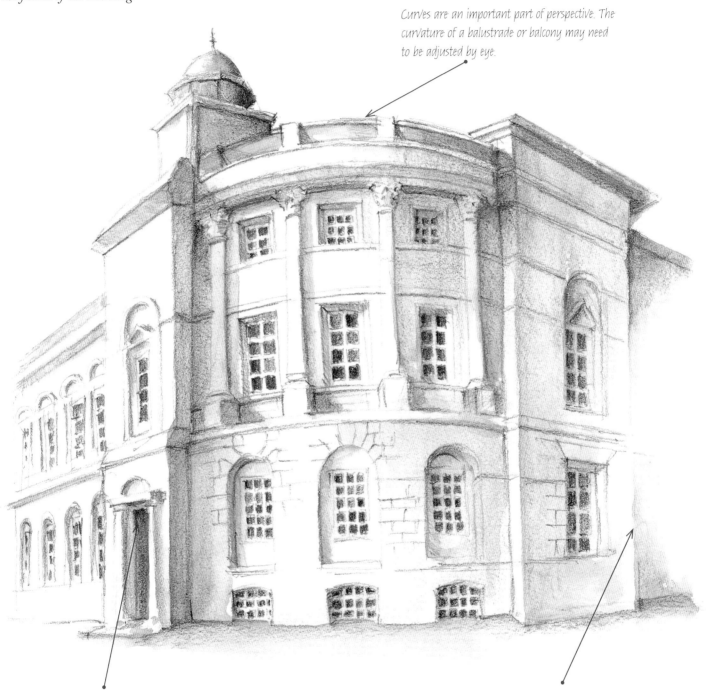

It is not just the framework that needs to look stable and solid. The windows and doors also need to be visually corrected.

It is important to ensure that the outer vertical lines of the composition are upright, as they frame the central detail.

Wideangle view

The human eye has a limited angle of vision. This is more than adequate for most views, but if you wish to extend this angle of vision you will need to twist your head. For most people, this rarely poses a problem. For artists, however, even the slightest movement can change the entire perspective. So how can you create a drawing of a long line of buildings without creating distorted and confused perspectives? The answer is to break the scene down into chunks, sketching one at a time and assembling them at home.

Many high streets contain a wealth of appealing buildings, all with their own individual features and characteristics. You can begin to record these by positioning yourself directly in front of your first chosen shop and making a thumbnail sketch. Don't worry about perspective: just draw the building as you see it, including any parked cars or shoppers (since they are an important part of the environment). Then, move along to the next building and position yourself directly in front of this, and sketch head-on. It is important that you try to maintain the same eye level (don't stand up for one sketch and sit down for another), and the same distance from the shops. Continue this along the street until you have collected as many thumbnail, flat-on sketches as you wish.

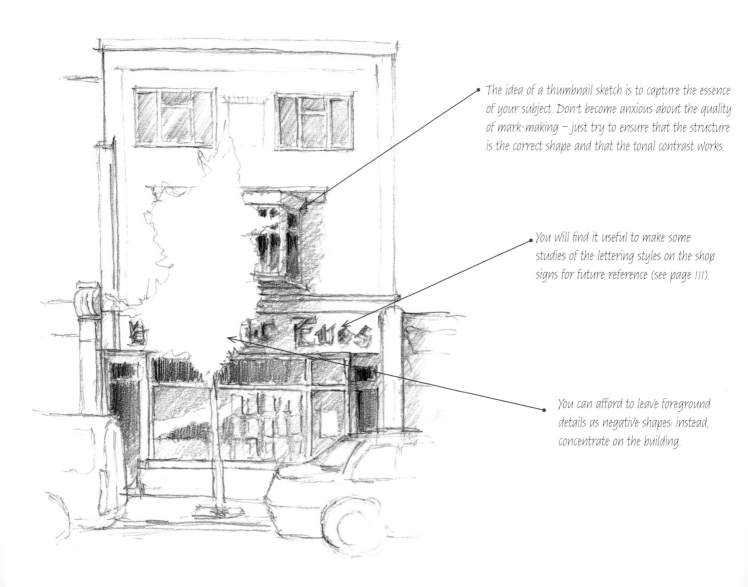

The idea of a thumbnail sketch is to capture the essence of your subject. Don't become anxious about the quality of mark-making – just try to ensure that the structure is the correct shape and that the tonal contrast works.

You will find it useful to make some studies of the lettering styles on the shop signs for future reference (see page 111).

You can afford to leave foreground details as negative shapes: instead, concentrate on the building.

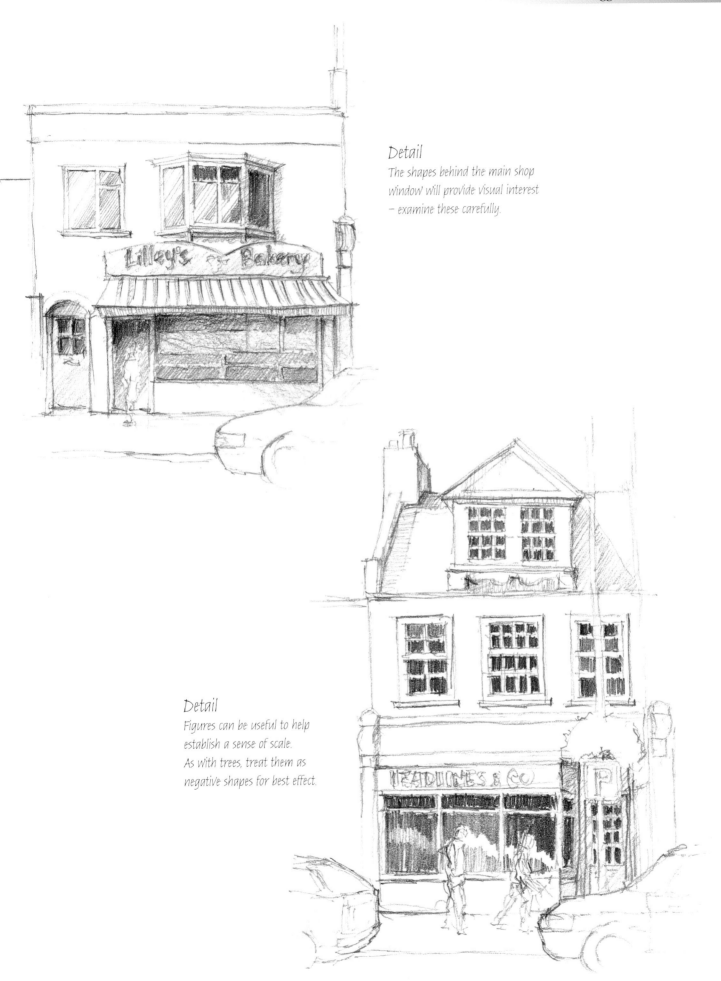

Detail
The shapes behind the main shop window will provide visual interest – examine these carefully.

Detail
Figures can be useful to help establish a sense of scale. As with trees, treat them as negative shapes for best effect.

Wideangle view *continued*

Having collected all of your sketches, you will have a great amount of visual information to process. As you begin to visualize just how these will look pieced together, it will soon become clear that the next stage will require some manipulation and creative thinking on your part. You might like to start by laying a sheet of tracing paper over each thumbnail sketch, and tracing the key features and structure – don't concern yourself with details in windows at this stage. You can then re-trace these on to a larger sheet of paper, joining each sketch with the next to recreate the length of the high street in panoramic format. You will now see that many perspective irregularities will exist. This is an invariable result of sketching head-on, one building at a time, as each building will contain its very own, individual perspective structure. You will also find that the other elements, such as cars, trees and figures, don't match up exactly.

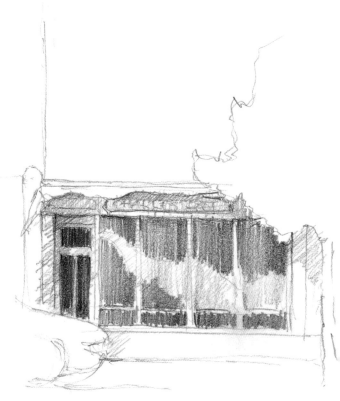

Detail
Reflections can take on some interesting shapes, creating abstract patterns within a glass windowpane.

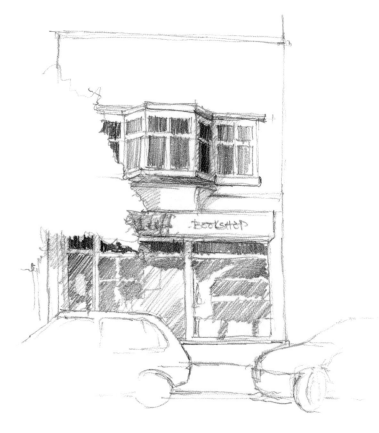

Detail
Vehicles are a vital part of any high street: however, only include these if they do not block your vision too much.

Information Gathering

There are many ways to gather all the information that you will need to complete a picture in your own home. Thumbnail sketches are invaluable, but can be enhanced considerably by a selection of colour studies. These can be made in any media you choose – as long as they provide you with a good record of the colours observed. I strongly advise you to experiment with these as they are quick, effective and easy to produce.

Pencil studies of specific details are useful, but they do not contain invaluable colour information.

Watercolour studies are always useful to inform us about the overall look of the scene; colour often strengthens an image.

Coloured pencil can be more practical and more convenient for on-site work.

Matching pencil colours with the colours of the subject can sometimes be tricky.

Some media look similar in their raw state, but the outcome of washing with water-soluble pencils can alter the final appearance considerably.

Experimenting with similar tones and colours is a useful way of exploring your chosen media.

Background colours are important to highlight the lettering colours; typography is often very characteristic and worth paying attention to.

Water-soluble pencils offer the best of both worlds – linear shapes and soft washes.

Wideangle view *continued*

The next stage in creating this wideangle view is to start at one end of the row and reconsider the perspective. The easiest solution to this problem is to simply remove any hints of perspective and flatten each building. You will also need to make some compositional decisions. How many cars and figures, for example, will you include?

Once you have fully established the line of buildings, and are happy that the overall scene is just the one you were seeking, you can return to your initial thumbnail sketches for information.

Start by exploring the differences between each building in the row. These will usually be evident in the structure of the windows, especially above the shop floor level. Working steadily along the row, draw these on to the skeletal outline to produce a detailed line drawing.

Next you will need to make a creative decision. The lighting may vary (albeit only slightly) in your sketches, or may not be clearly defined. You will have to decide where the light is coming from, its angle and its intensity. Then you can begin to draw the main shaded areas inside doorways and underneath window ledges. Make these as dark or as soft as you wish.

The final stage is to develop the scene by creating the shading and reflections in the windows, adding tone to the cars and trees, and adding shadows to the foreground, defining both the pavement and the road along which the buildings are set. Your final drawing will be a fascinating composition of shapes, blocks and detail, viewed in a way that most people will rarely see.

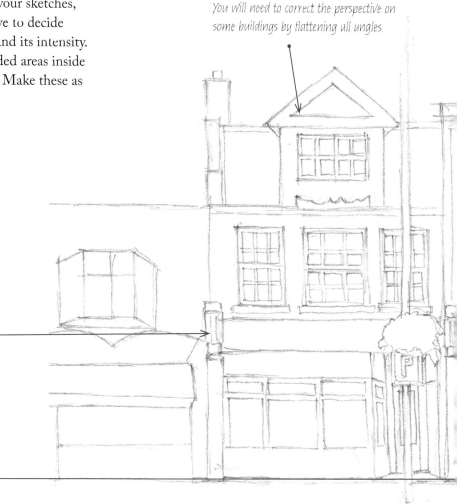

You will need to correct the perspective on some buildings by flattening all angles.

Start by putting together a simple line drawing – with no detail – just check that all buildings are aligned.

You may need to piece together the backs and fronts of vehicles to produce a visual break in the foreground.

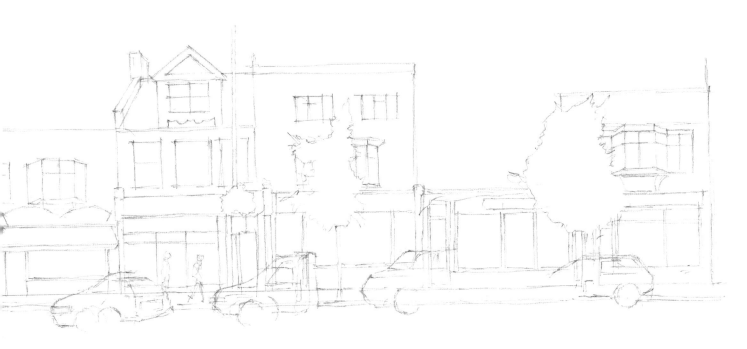

High street shopping row
Putting together a wideangle view involves much cross-referencing and alignment at the preliminary stage. Take some time over this.

When you begin to develop trees, it is important to isolate the highlights and shade behind them using three levels of tone: medium, dark medium, and very dark.

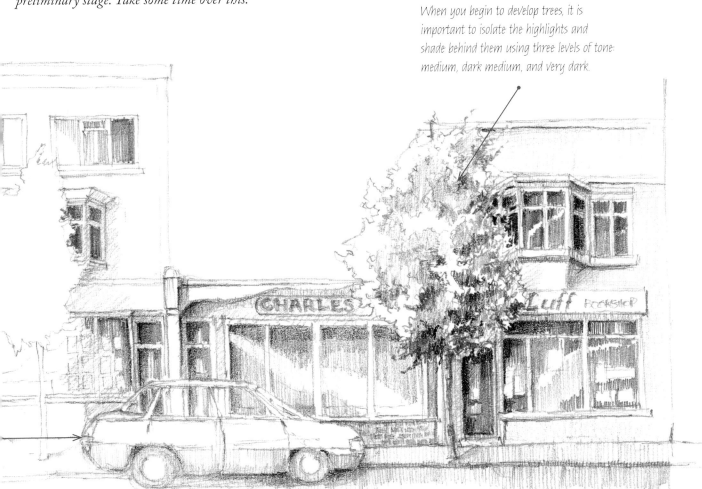

Panoramic view

Sometimes you will be struck by a view that is so vast that you know that you will not be able to absorb the vista in one go – or you are at the top of a multi-storey car park on your way to work and couldn't even consider stopping to make sketches. This is where a small, pocket-size camera can come in handy as an aid to recording.

To make these shots work, you will need to keep the camera at the same level as you pan around the scene. Take as many overlapping photos as you feel you may need, some portrait and some landscape format. I find that this procedure works best if you keep your feet still and just twist your upper body gently with each photo.

Once you have your photos developed, you can begin to piece together the jigsaw puzzle of shapes, lining up and butting together as appropriate.

It is unlikely that you will wish to use all of the visual information made available to you with one photograph, let alone a selection. Unlike the wideangle view, you may find that creating a freehand sketch of the particular section that interests you gives a more satisfying result than tracing from your joiner.

Try to view the rooftops as abstract shapes, working together to create a patchwork of angles and curious geometry. Keep the drawing simple for now, as you are still at the planning stage of the composition – you may wish to make changes, so leave the detail for now.

Structure
The initial pencil drawing concentrated on the patchwork design that was created by the rooftops and chimneys. Other details could wait until the main framework of the drawing was laid out.

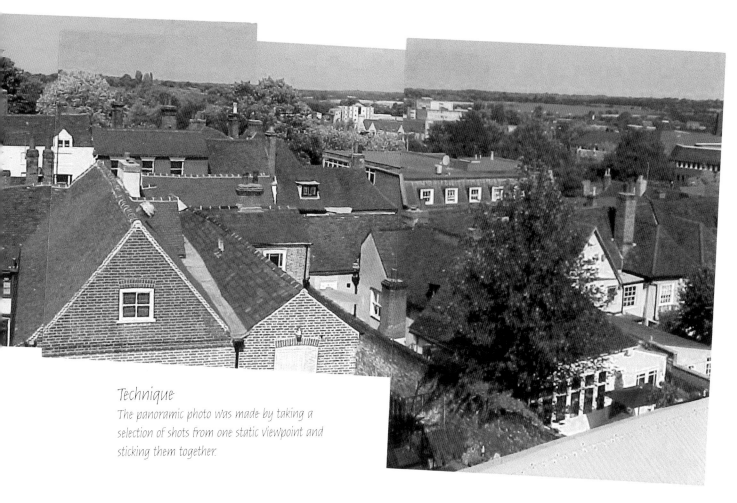

Technique
The panoramic photo was made by taking a selection of shots from one static viewpoint and sticking them together.

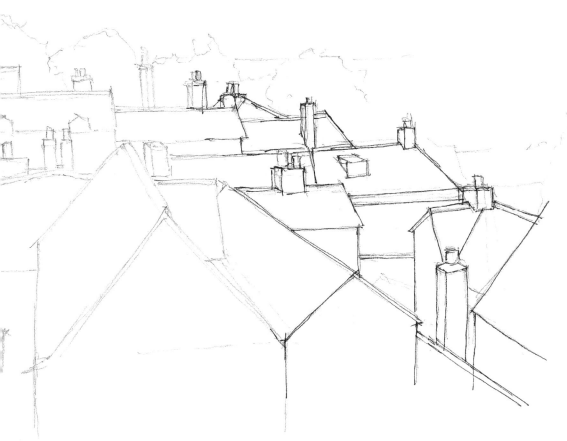

Technique
The final drawing was created by drawing over the pencil lines with a waterproof ink pen.

Panoramic view *continued*

To make scenes like this work you will usually need to include both the background trees and landscape and the sky in the final drawing.

The first stage in this process is to mix up a watery solution of cobalt blue – this is a thin blue that is particularly well suited to painting distant skies. Wash this across the horizon with a large, wet brush. Don't try to create any detail here – just tint the sky to indicate that it exists. Then, mix a wash of sap green (this is a natural-looking, soft green that is also good for objects in the distance) and apply this to the line of trees. Before this dries, add a touch of raw sienna to the green wash and dab this into the trees. This new colour will bleed into the trees, adding a variety of soft tones. As the background should be a backdrop against which you will view the main subject (the rooftops), you will not want to spend any more time on this section.

The next stage is to apply colour to the rooftops. Wash these paints on to dry paper using broken brushstrokes; don't be concerned if they bleed.

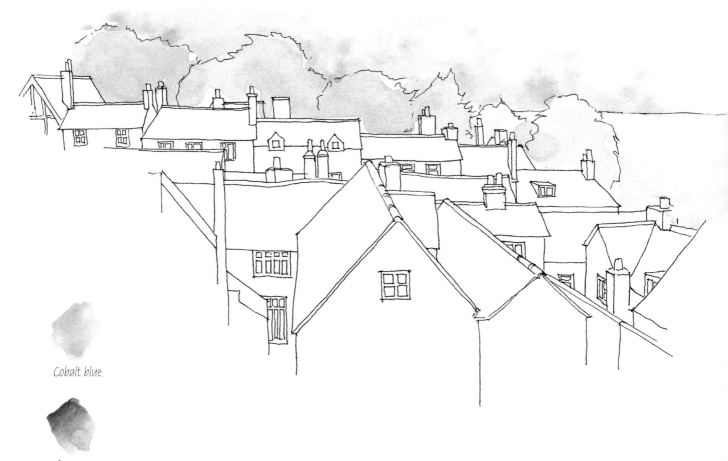

Cobalt blue.

Sap green.

Raw sienna.

Colour

For the sky, use broken brushstrokes to allow a little white paper to show, to suggest vague clouds. Don't be concerned if the background tree colours bleed slightly into the sky colour: this just adds to the sense of freedom and the spontaneity of the drawing.

Raw sienna.

Burnt sienna.

Cobalt blue.

Burnt umber.

Colour

The initial wash should not necessarily follow every line. Allow a few flashes of white paper to show through, and a few colours to run into others. Mix the colours that you see; raw sienna and burnt sienna mix well to give a good tile colour, while cobalt blue and burnt umber create a good slate mix.

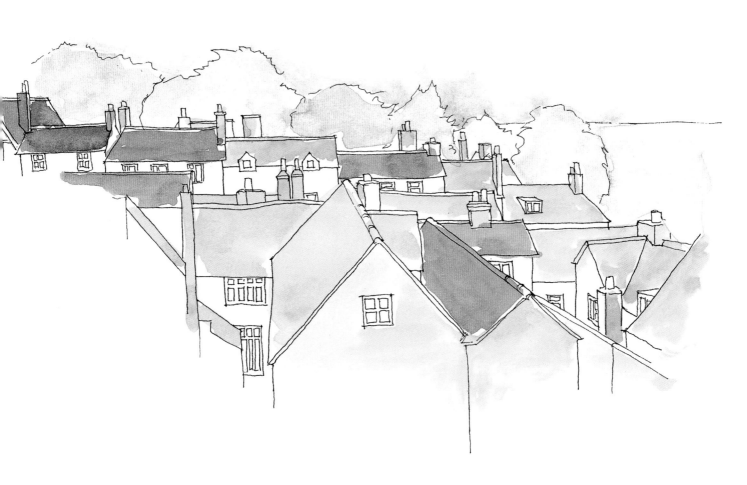

Panoramic view *continued*

Once you have established the basic outline and an underwash, you can begin to develop the main part of the drawing.

To ensure that a sense of distance across the rooftops is maintained, it is important to vary your mark-making techniques. Keep your drawing minimal in the background – just a few short, sharp marks to suggest the lines of roof tiles will suffice. If you draw too much detail in the background, you will visually overload the picture. This will also force you to overdraw the foreground to maintain the difference between these two distinct sections of the composition.

You will also want to develop the patchwork pattern of colours and shapes by washing the shadows on to the drawing. On a clear, sunny day you can expect to be able to see clearly defined, hard-edged shadows cast downwards on to the walls of the buildings.

To create a convincing shadow colour, you will need to mix most of the colours used in your picture together, with the blue being the most dominant. This grey mix can then be applied to dry paper with a medium-sized brush, using a once-only, positive brushstroke. This will help to create the hard edges that are required.

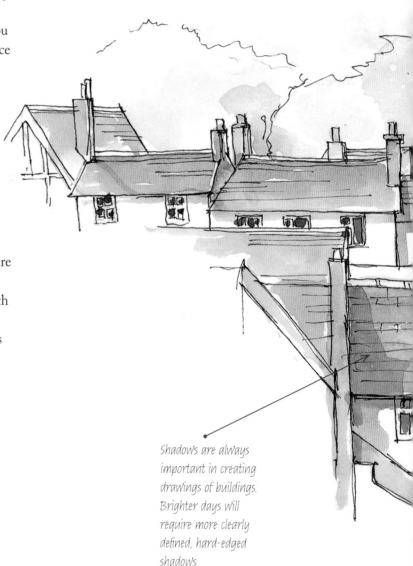

Shadows are always important in creating drawings of buildings. Brighter days will require more clearly defined, hard-edged shadows.

Smoky rooftops

The success of this drawing relied on the subtle balance maintained between the softness of the watercolour wash and the reliable solidity of the pen lines. Once the washes had dried, I concentrated on the finishing touches by drawing a few lines of tiles on to roofs and suggesting brickwork on the walls. This created the all–important contrast between the clearly defined foreground and the slightly more hazy background.

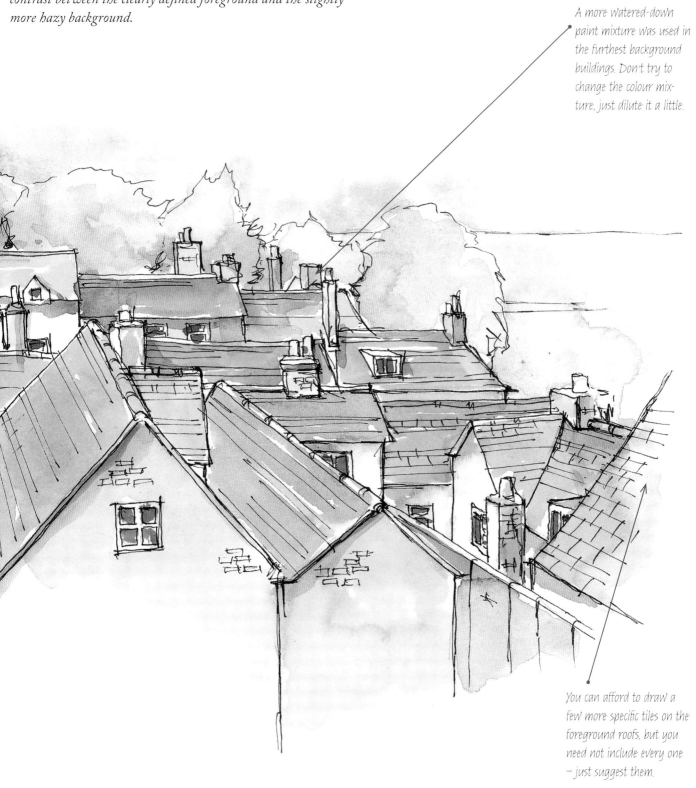

A more watered-down paint mixture was used in the furthest background buildings. Don't try to change the colour mixture, just dilute it a little.

You can afford to draw a few more specific tiles on the foreground roofs, but you need not include every one – just suggest them.

Final thoughts

Throughout this book, my aim has been to inspire you to seek out the true character of buildings in rural and urban environments, and to offer a range of techniques for you to develop and make your own. Along with this should come the confidence to take your sketchpad outside with you and to draw the buildings in their own environment. This can, however, be a very solitary activity. If you are not already a member of an art group, club or class, then you might like to consider joining one.

If this seems a little intimidating, then you can always start sketching in the privacy of your own back garden or yard, or on your own balcony. Although you may not view your own home as being worthy of a drawing, you will find that you can at least practise on it – and you may even pleasantly surprise yourself with the result.

When you are out on the street for the first time, try to remind yourself of some of the early lessons set out in this book. Try to distil the scene, remembering that the building you are drawing is, in terms of its structure, probably little more than a box or, at its most complex, a couple of boxes set on top of each other. What could be simpler than that?

On another note, the environment that you find yourself in and the buildings that you record in your sketches will harbour memories of hundreds of years, silently bearing the testimonies of many generations. The current residents may also feel that way, but may be concerned to look out of their windows to see someone sitting in a car, apparently making notes about their home. There is little that you can do about this other than to be open and welcoming to any resident who might feel the need to question your activity. These are the times to ensure that common sense prevails, and sensitivity should be a major consideration.

On a final note, you can learn to draw – maybe not overnight, or even within a week. But perseverance will pay off, and I sincerely hope that the information contained within the pages of this book will help both to instruct and inspire you.

So it's over to you now. I wish you great success and much pleasure from your drawing.

Richard Taylor

Glossary

CARTRIDGE PAPER A thick, strong paper. It was originally used to hold gunpowder, but is now used for drawing because of its texture and durability.

DRAUGHTSMAN'S PEN A type of pen that has a fixed metal nib and that contains cartridges of Indian ink. These are good-quality drawing pens.

EAVES The underside of a projecting roof. These will always cast a shadow, and will strongly influence the way in which you draw a building.

GRAPHITE A dark grey powder, derived from carbon, that can be found in powder form or compressed for pencils.

INDIAN INK A black ink with strong dyeing qualities. It can be used with a pen for line drawing, or diluted with water to create a tonal wash.

ITALIAN RENAISSANCE The period in the 15th and 16th centuries when artists joined in the explosion of enquiry into the world they inhabited, and sought to further their craft by producing manuals, guidelines and rules.

NATURAL EARTH COLOURS Colours that are created from pigments dug directly from the earth – including umbers, siennas and ochres – and therefore holding the same qualities as the building materials dug from the earth.

PANORAMA An unbroken view of the surrounding area, not usually accessible to human vision from one static viewpoint alone.

PERSPECTIVE A series of conventions created by artists to allow three-dimensional views to be recorded convincingly on a two-dimensional surface.

PUSH–PULL The effect created when the darkening of one shape appears to push a lighter shape forwards into the foreground of a drawing.

PUTTY RUBBER A highly pliable eraser that will lift graphite from paper without damaging the surface.

TERRACE A row of houses, usually built in a single block, and generally in uniform style.

THUMBNAIL SKETCH A small, rapidly executed sketch to act both as a visual prompt and for further reference.

WIDEANGLE A view containing a wider field of vision than is normally available to the human eye.